RENOIR

LIFE AND WORKS

D0357199

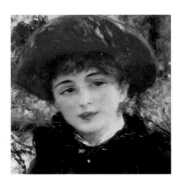

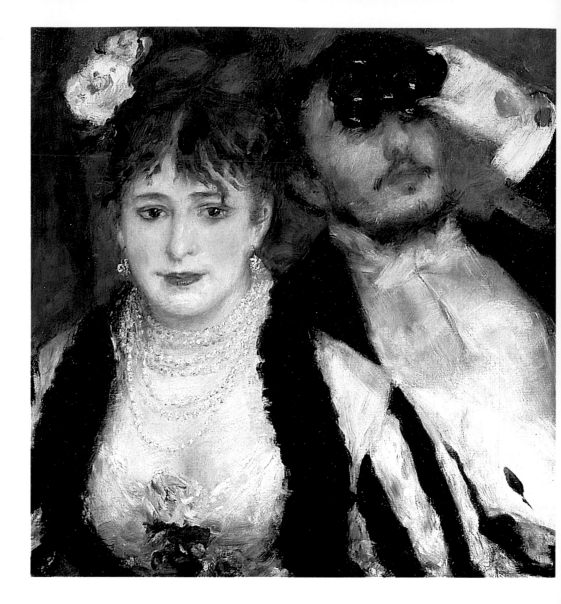

RENOIR

LIFE AND WORKS

PAUL JOANNIDES

SOURCEBOOKS, INC.®
NAPERVILLE, ILLINOIS

Copyright © 2000 MQ Publications Ltd
Cover design © Bet Ayer

Series Editor: Ljiljana Ortolja-Baird
Editor: Andrew Brown
Designer: Bet Ayer

All rights reserved. No part of this book may be reproduced in any form
or by any electronic or mechanical means including information
storage and retrieval systems–except in the case of brief quotations
embodied in critical articles or reviews–without permission in writing
from its publisher, Sourcebooks.

Sourcebooks, Inc.
P.O. Box 4410, Naperville, Illinois 60567-4410
(630) 961-3900
FAX: (630) 961-2168

Printed and bound in Italy

MQ 10 9 8 7 6 5 4 3 2 1

ISBN: 1-57071-692-7

Contents

Introduction

P ierre-Auguste Renoir (1841–1919), despite his very widespread popular appeal, has proved the most problematic of the leading Impressionist painters for modern critics, who have sometimes dismissed his work as 'chocolate-box' art. The only one of that loose group whose origins were proletarian, Renoir was probably the least class-conscious. He was wide-ranging in his personal sympathies, and although he became increasingly conservative as he grew older, his was a conservatism without misanthropy – unlike that of Edgar Degas (1834–1917). An impulsive, nervy, and talkative man, Renoir often expressed contradictory opinions, but his loyalties to his family and friends were constant. With minimal secondary education, he was the Impressionist whose response to the forms of antique sculpture and to the subject matter of ancient myth was richest and deepest – indeed, although frequently disguised, classical themes run throughout his art. Of all the Impressionists, Renoir portrayed most consistently the experience and pleasures of 'ordinary' people, but portrayed them without a social or political agenda. He avoided both the detachment of his close friend Claude Monet (1840–1926) and the quasi-scientific observation of Degas. And alone among the Impressionists, Renoir maintained throughout his life the great tradition of life-size figure painting, at times discarding 'Impressionist' values to do so. All this has made Renoir and his work hard to grasp.

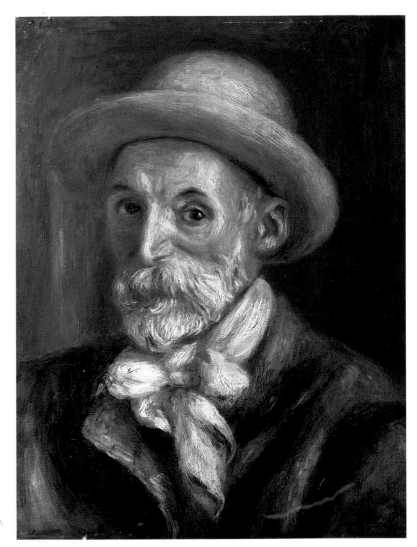

Pierre-Auguste Renoir,
Self-portrait, 1910, oil
on canvas, 47 × 36 cm,
Private Collection

Part of the difficulty results from Renoir's changeability and lack of commitment to any single line of investigation. It would be only a slight exaggeration to say that he began every picture from scratch. Unlike his colleagues, he referred openly to tradition: his work contains many echoes of past masters, of Sir Anthony van Dyck (1599–1641), Diego Velázquez (1599–1660), François Boucher (1703–70), Jean-Honoré Fragonard (1732–1806), among others. But if Renoir lacked the relentless single-mindedness of Monet or Degas, his variety was also a strength. He has a capacity to surprise that they rarely display. It is significant that the single theory that this least theoretical of painters briefly attempted to propagate was a self-explanatory coinage of his own: Irregularism.

Renoir began his career as a teenager. In the 1850s he worked as a pictorial artisan, a painter of china, and the techniques he learned at that trade were often employed, modified and developed, in his later paintings. For instance, he made much use of thin glazes, washed like watercolor over the bright surface of the prepared canvas, against which he set more-thickly painted areas. Textural disjunctions characterize Renoir's paintings, in opposition to the homogeneous surfaces generally striven for by his friends. Furthermore, since much china decoration involved the repetition of images by the eighteenth-century French painter Jean-Antoine Watteau (1684–1721) and his followers, Renoir's five-year apprenticeship also introduced him to what was to become a major theme of his later work. This was the *fête galante* - the depiction of courtship in parkland settings - whose subject of discreet amorousness and perpetual picnicking struck in Renoir a powerful chord.

In the early 1860s, Renoir abandoned this work and embarked on the career of a serious artist. The determination that this required, for a young man with few resources and without institutional support, must have been formidable. The qualities of his earliest pictures – like

those of early Impressionism generally – tend to be underestimated. They are profoundly adventurous and demonstrate an ambition to master the major currents of contemporary French painting: Classicism, Romanticism, and Realism. Renoir revitalized themes treated by the most important representatives of these movements, respectively Jean-Auguste-Dominique Ingres (1780–1867), Eugène Delacroix (1798–1863), and Gustave Courbet (1819–77). He achieved this in part by cross-referencing, painting subjects associated with one current in the pictorial style of another, and partly by constantly returning to nature. Towards the end of the decade Renoir began to paint landscapes and scenes of suburban leisure, but his largest and most ambitious paintings of this period focus upon the human figure and, above all, the female form in the person of Lise Tréhot.

Lise was Renoir's mistress from 1866 until 1872. Little is known about her, but her presence states the theme that was to remain central to Renoir's art: fascination with women. Clothed or nude, they dominate his painting, and while his treatments of them are rarely lubricious, they are often pronouncedly sexual. Lise was clearly vital to Renoir. She appears in his work in many different guises, as though he wanted to explore every facet of her body and personality: their affair must have been intense, even obsessive. When it ended, his art changed.

Following his break with Lise, the emotional temperature of Renoir's art cooled. He came to follow more closely the experiments with division of color and broken brushwork of Monet, beside whom he had already worked. The shadows cast by the Franco-Prussian War of 1870 and the ensuing civil conflicts, whose horrors had been particularly pronounced in Paris, were dissipated in sunlight: painting has rarely been more collectively joyous than in France in the mid-1870s. This was not simply bourgeois triumphalism after the destruction of the revolutionary Paris Commune: it registered the spirit of national renewal, both political

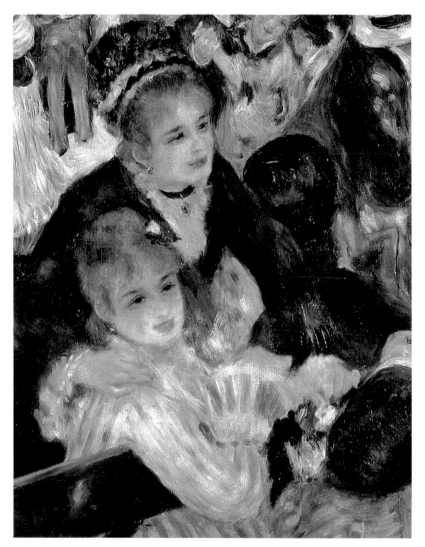

Pierre-Auguste
Renoir, detail of *Ball
at the Moulin de la
Galette*, 1876

and social, that had been encouraged by the new administration, the nascent Third Republic. Renoir painted many landscapes in these years, stressing the casual and immediate both in subject and technique, composing them more informally than Monet. He concentrated on immediacy of effect, most obviously in his *Gust of Wind* (*see pages 42–3*), and stressed the texture and surface of foliage rather than the architecture of earth and trees. But his most distinctive work deals with urban social life: the wide boulevards, boating parties, *bals populaires*, theatre, music. The fusion of figures and surroundings, in dappled light and shade, has a pervasive charm. Whatever the specific subject, Renoir's preoccupation is youth and vitality. His greatest painting of this decade, the *Ball at the Moulin de la Galette* of 1876 (*see pages 66–9*) is a *fête galante* of young workers and artisans, in which the shared pleasures of conversation and dancing are celebrated with animation and vivacity. Few paintings have ever conveyed more fully the pleasure of being alive.

Complementing his depictions of groups, Renoir also painted single figures of women against simplified backgrounds – *La Parisienne* (*see page 57*) and the *Dancer* (National Gallery of Art, Washington, DC) are two famous examples. Such paintings show that while the female body fascinated Renoir, he was far from ignoring mind and personality. His paintings of women reading, attending the theatre, and making music demonstrate a persistence of that interest in the mental lives of women that characterized French painting of the eighteenth century, Renoir's preferred period. Indeed, such paintings revive a particularly French tradition of 'egalitarian' portraiture. But Renoir's purpose was less to portray individuals as themselves – they are rarely psychologically penetrating – than as representative of social types. There are some visual similarities to the contemporary work of Degas, but Renoir's relation to his subjects is more direct and engaged. He shows them at their best, stressing surfaces but without superficiality.

Towards the end of the decade Renoir tried to enlarge the scale of the figures in his group paintings, and to compose them more tightly. This phase, one of great ambition, is best represented in the *Luncheon of the Boating Party* (*see pages 86 and 88-9*). The group dominates the picture surface: the figures are larger and more precisely characterized than in the *Moulin de la Galette.* But, although critics have attempted to uncover class or personal tensions among the participants, the meaning is the apparent one: *douceur de vivre*, friendship and companionship among a varied group of men and women who enjoy each other's company. Allied in spirit, but more concentrated, are Renoir's three life-size panels of couples dancing (see *pages 92–97*). The couples differ in class, the dances differ in locations, but none is satirized: Renoir seeks to evoke a universal pleasure.

The endeavor to enlarge his forms was one of the reasons that Renoir's art underwent a change in the next decade. But this change also reflected a general crisis among Impressionist painters in the 1880s. The problem they faced was essentially that of the relation of form and flux. Impressionism was about movement of light, instability of solids, reflection of colors, interrelation of substances. But this was obviously inimical to the creation of clear form. Camille Pissarro (1830–1903), Monet, and Renoir all experienced uncertainty. Pissarro followed the example of a younger artist, Georges Seurat (1859–91), who took the principle of broken brushwork and pure colors to an extreme by building up his paintings with thousands of tiny dots of pure pigment. But dissolution of form into particles of color had to be counteracted by an extreme simplification of design: the late work of Seurat looks like poster art. Some of Pissarro's paintings in this mode are very beautiful indeed, but they have little to do with natural appearances. Monet investigated ever more transient effects of light, but increasingly took as his motifs structures of permanence and solidity.

For Renoir the task was different. Whereas his comrades were primarily landscapists, he was first and foremost a figure painter. In order to construct his paintings more precisely, and to attain greater control over their staging, he had to develop and expand his draftsmanship. This led him to study the traditions of Renaissance and post-Renaissance art, especially those of articulated and expressive figure-drawing. Renoir's progress was neither steady nor easy. A trip to Italy in 1881 shook him but was salutary. He went to see Raphael's famous *Madonna della Sedia* (Palazzo Pitti, Florence) – a supreme example of tight composition – and, intending to mock it as artificial and sentimental, was shocked to discover an admirably direct and straightforward piece of painting. Raphael's *Madonna* is clearly echoed in Renoir's picture of 1885 of his young companion Aline Charigot and their child. Renoir's vision from this time on becomes more domestic and familial, the maternal playing an increasing role. He also much admired Raphael's great voluptuous nudes in the Villa Farnesina in Rome, and the nude gradually assumes a dominant place in his art.

Renoir exhibited less in the 1880s. His work from that decade is inconsistent. Some paintings were executed in a richly textured style, others in a much harder manner, with fused, almost ceramic surfaces. A few paintings combined both techniques. He made many more drawings than before and attempted to refine his capacity for figural expression. Renoir also found inspiration in the efforts made by Paul Cézanne (1839–1906) to achieve more strongly structured paintings. Although he had previously painted individual nudes, Renoir's group pictures had been composed from clothed figures, which were easier to organize. But he persisted and in the *Bathers* of 1887 (*see pages 104–7*) he successfully rendered solid living flesh within a spacious landscape. The *Bathers* is one of Renoir's masterpieces, the first great statement of what might be called his Mediterranean

phase, which extends until the end of his life. But Renoir's great difficulty in composing such a painting is indicated by the fact that he had to borrow his figural arrangement from one of the icons of French classicism, the famous fountain relief by François Girardon (1628–1715) of *Bathing Nymphs*, now in the gardens of the Palace of Versailles.

The massive achievement of the 1870s and the intense struggles of the 1880s took their toll. By 1890 Renoir had begun to suffer from a rheumatic illness that was to dominate his life and put him in a wheelchair. His failing health must be borne in mind when assessing the work of his last 30 years. He gradually abandoned large group compositions, although a few exist of his family. He focused instead on portraits, still lifes, landscapes, and studies of women, clothed and unclothed. His style was now a synthesis: the color range reduced and increasingly hot; the modeling often achieved by the admixture of black, that is, by tone – a technique anathema to the Impressionist aesthetic – albeit tone suffused and enriched by skeins of color. His flesh-painting was streakier and darker, with less interest in local light effects. In the course of an over-extensive production of small works, Renoir's interest in the analysis of natural appearances and in the world outside his own household diminished. The backgrounds to his studies of the nude in the open air are sometimes perfunctory. He paid more attention to the decorative, and some of his loveliest later paintings, like those of one of his favorite artists, François Boucher, were planned for specific interiors. But what may seem to be merely decorative, when examined, is often found to contain a richness of thought and a coherence of symbolic reference that help to explain why the ageing Renoir could describe himself, only half-jokingly, as a poet.

Most notable however is the continual portrayal of women, an expression less of sexual desire than the need of a man, whose limbs were slowly petrifying, to reassert his hold on

life – life that was, for him, most perfectly embodied in the female body. After 1900 his response to specific models lessens, the scale of figures in relation to the picture surface expands, flesh takes on red-brown hues, and bodies develop a primeval massiveness that looks forward to the classical period of Picasso – who greatly admired Renoir's late nudes and who owned several examples. The skin of his models had once fascinated Renoir; now it was their abundant flesh which took command. Renoir represented relatively few overtly classical themes, but his subjects are nonetheless frequently generalized from antique examples. Renoir's classicism has a close relation with that of his younger contemporary, the sculptor Aristide Maillol (1861–1944), with its emphasis on weight and mass rather than contour, amplitude rather than elegance; the increasingly sculptural nature of his painting naturally led to experiments with sculpture, which Renoir 'dictated' to an assistant. The inflation of the female form was also Renoir's way of registering nature's fecundity. His final masterpiece, *Large Bathers* of 1918–19 (*see pages 138–9*), executed by a man who had lost the use of his hands and worked with brushes strapped to his wrists, is a vision of harmony. The women's bodies brim with health: strongly muscled, they are wonderfully equipped for life. They seem as much products of the earth as the surrounding foliage. Their wealth of form and the hot landscape in which they recline fuse present and past. Renoir's last major painting is one of the peaks of a fascination with the nude in nature that runs through later nineteenth-century French art, from Courbet to Cézanne; simultaneously it is a return to the earliest representation of women, the wide-hipped figurines of neolithic art. And in this final revitalization of Classicism – his artistic testament – Renoir also revisited his own past: 50 years on, he recreated in a new form the vision of his earliest nudes, his paintings of Lise.

The Early Paintings

PAINTINGS OF THE 1860S

Mademoiselle Romaine Lacaux 1864

31½ x 25¼ in

Oil on canvas

Cleveland Museum of Art, Cleveland, Ohio

Renoir, at the age of 24, already demonstrates both his pictorial acuteness and his sympathetic understanding of children in this portrait of a nine-year-old girl. The silvery effect, compounded of subtle blues, greys, and off-whites, is enlivened by the red splash of peonies on her lap. The swell of the chemise is held in check by the sharply focused trim of the dress, whose high belt contributes to the viewer's sense of the young girl's training. The vase of flowers on the right is flattened as though it were wallpaper: nature and artifice fused with a wit that recalls French painting of the eighteenth century.

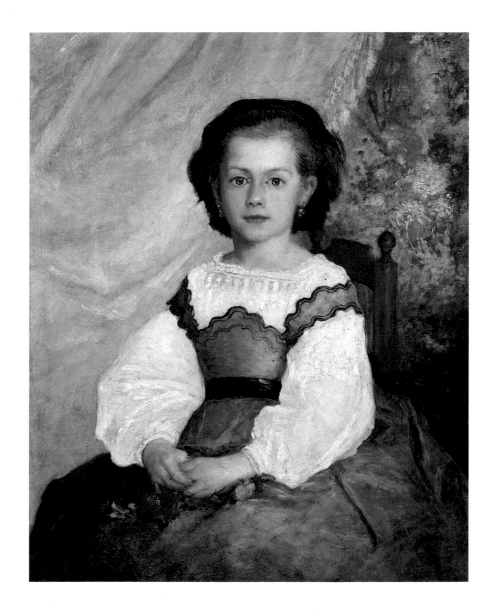

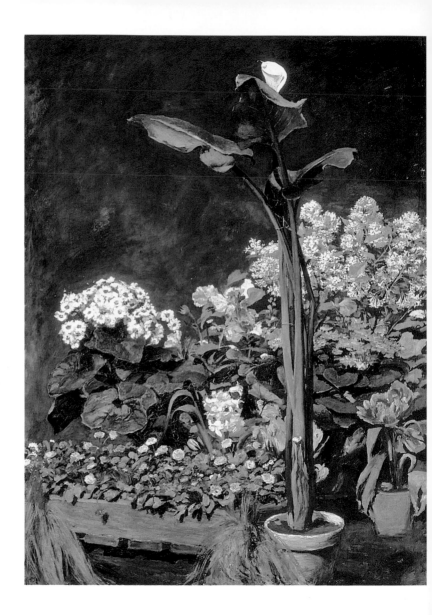

Arum Lily and Hothouse Plants 1864

50¾ x 38¼ in

Oil on canvas

Oskar Reinhart Collection, Winterthur, Switzerland

This unusually large close-up still life is one of two canvases of
identical sizes showing the same section of a hothouse – seen
from different angles – that Renoir painted in 1864. The boldness
with which this version is composed – the flower-pot that holds
the arum lily is half cut off; the lily itself rises to the top of the
canvas, as if governing the other plants – gives it great vigor
and dynamism. Unusual is Renoir's emphasis on the body of
the plants rather than their flowers, demonstrating a capacity to
create solid forms that he did not often exploit.

Frédéric Bazille at his Easel 1867

41 x 28½ in

Oil on canvas

Musée d'Orsay, Paris

One of the most inventively designed of his early works,
Renoir's portrait shows the very tall Frédéric Bazille – who
would be killed just three years later during the Franco-Prussian
War – hunched concentratedly over his easel, with an intimacy
that only a close friend could achieve. The pose is slightly
undignified but deeply sympathetic.

Renoir shows Bazille working on his still life *Dead Herons
and Falcons*, a subject painted simultaneously, but from a
different angle, by another Impressionist, Alfred Sisley (1839–99).
Behind Bazille hangs *Snow Scene* by Claude Monet. Renoir's
picture thus evokes the interaction among the Impressionists,
and their close links of friendship, as well as of aims and ideals.

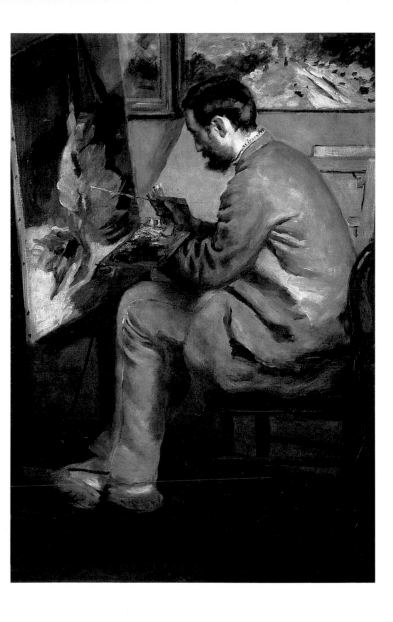

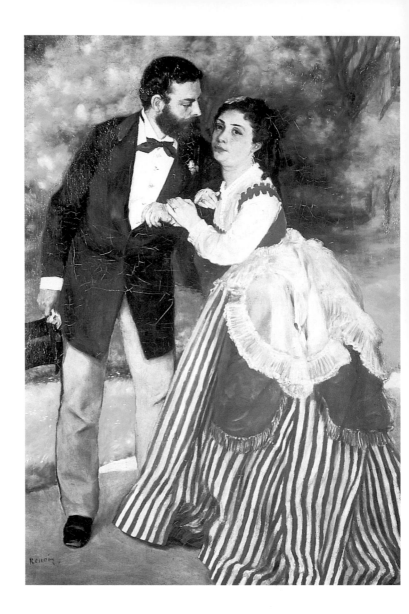

The Engaged Couple *c.* 1868

41¼ x 28¾ in

Oil on canvas

Wallraf-Richartz Museum, Cologne

Although the couple fill the pictorial surface, this is not a conventional double portrait, which would be life-size and treated in a more static way. The man is known to be Alfred Sisley, but there is uncertainty about the woman's identity. She may be Sisley's mistress, who had recently borne him a child; however, she also resembles Renoir's own mistress Lise, which supports the view that the painting was planned not as a portrait but as a modern subject picture, in which Renoir simply employed his friend and his lover as models. It seems to show the beginning of a promenade, a theme Renoir was frequently to treat: perhaps he saw the painting as illustrating the beginning of the couple's passage through life.

Bather with a Griffon Dog 1870

71¾ x 44¼ in

Oil on canvas

Museu de Arte de São Paolo 'Assis Chateaubriand',

São Paolo, Brazil

While the pose of the nude woman – Renoir's mistress Lise – is that of the famous antique statue the *Medici Venus*, the scene is clearly reminiscent of work by Gustave Courbet, notably his *Bathers* of 1853 and *Young Women by the Banks of the Seine* of 1857. But the pictorial treatment, with feathery brushstrokes and lush handling, makes clear reference to the great eighteenth-century French painter Jean-Antoine Watteau. In this mix of Classical, Realist, and Rococo, Renoir combined in a single work subjects and visual themes that were to run through his art. As in Courbet's two paintings, a narrative is implied but not clarified for the viewer. This combination of provocativeness and reticence is a characteristic feature of advanced figure painting in the 1860s, and is certainly among the reasons why critics attacked it.

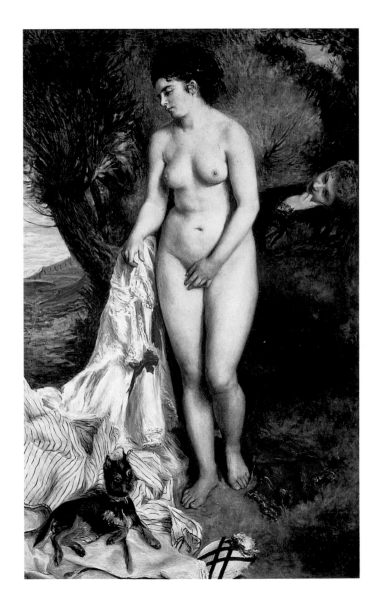

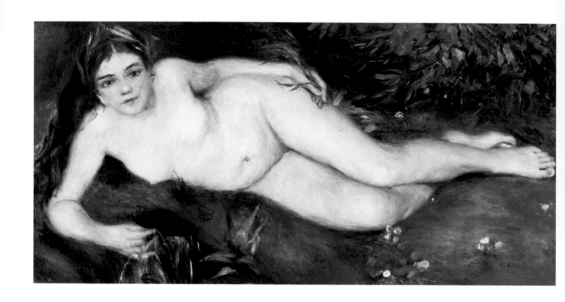

A Nymph by a Stream *c.* 1870

26¼ x 48 in

Oil on canvas

National Gallery, London

This image can be seen as a narrative continuation of the previous picture. Lise has now emerged from the stream and lies on its bank. On the one hand, Renoir has painted a realistic picture of a young woman; on the other, he has cast her as a water-nymph, crowned with a circlet of leaves, looking up at the artist – and the male spectator – with a clear erotic invitation. The associations of water and sexuality combine with that of danger: nymphs can drag their lovers to their deaths. The mythical dimension is not emphasized, but its understated presence gives an edge to what seems at first sight a straightforward figure study.

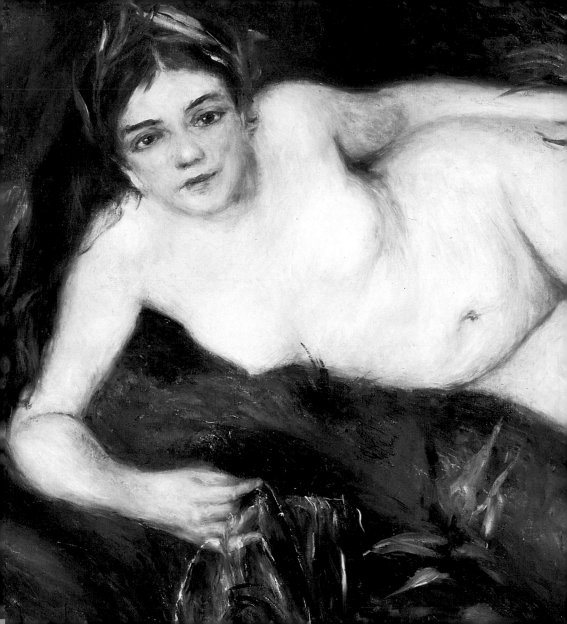

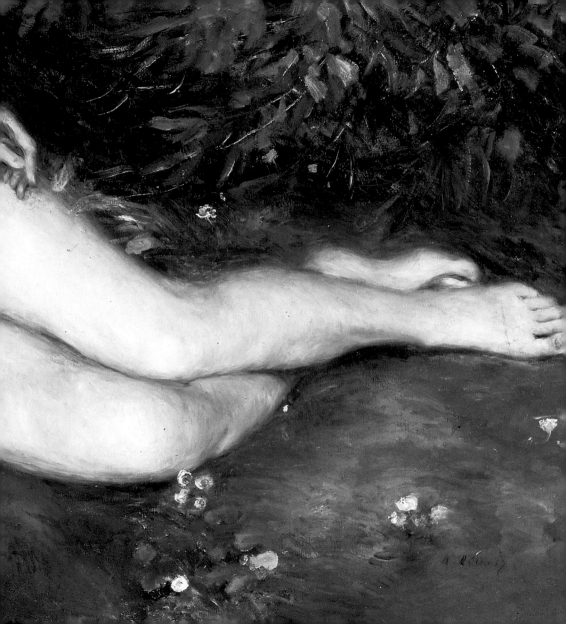

Portrait of Rapha 1871

50¾ x 32¼ in

Oil on canvas

Private Collection

This portrait is unusual in Renoir's early work in the elongation
of the figure, the angularity of her draperies, and the wide-angle
view, which makes it appear that the subject is about to slide out
of the picture. The trellis-work wallpaper, the high wainscotting,
and the large birdcage divide the space and seem to confine
the sitter; and the flowers that jut into the lower left corner intrude
upon her. The inspiration for this organization came from
Japanese prints, as the fan clearly indicates, but the general
conception and the thick pigment with which the dress is
painted are indebted to the work of Édouard Manet (1832–83)
and James Whistler (1834–1903), both of whom were fascinated
by *japonisme*.

Rapha was the mistress of Renoir's friend Edmond Maître –
another example of the unconventional relationships common in
Renoir's circle – but the claustrophobic composition, Rapha's
mood of *ennui*, and the motif of the caged bird, imply that the
relationship was not altogether happy.

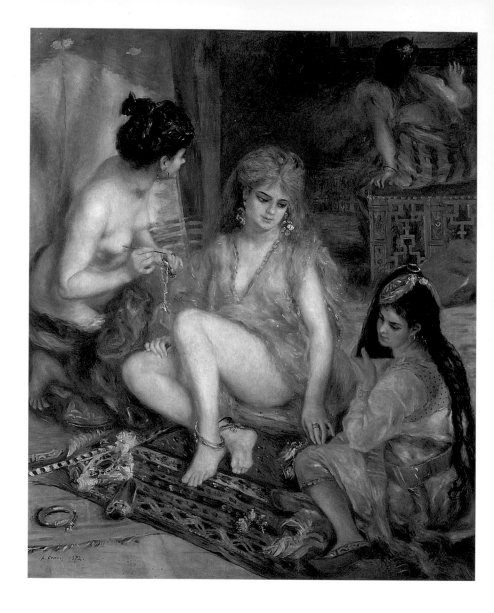

Parisian Women in Algerian Dress 1872

60¾ x 50¼ in

Oil on canvas

National Museum of Western Art, Tokyo

This is obviously an adaptation of Eugène Delacroix's famous painting of 1834, *Les Femmes d'Alger*, but done in deliberately fancy-dress manner. In contrast to Delacroix's direct reportage, Renoir's painting plays on the erotic-exotic associations of the harem as a site for the free play of desire. And, in casting three young *parisiennes* as its occupants, Renoir transfers the idea of erotic availability and erotic role-playing to Paris: he may be suggesting, discreetly, the context of a brothel. Two years earlier Renoir had painted Lise as an overtly sexy *Odalisque* (National Gallery of Art, Washington, DC) and although they had parted by the time this picture was completed, she probably provided its initial inspiration.

The 1870s

PAINTINGS BETWEEN 1870 AND 1879

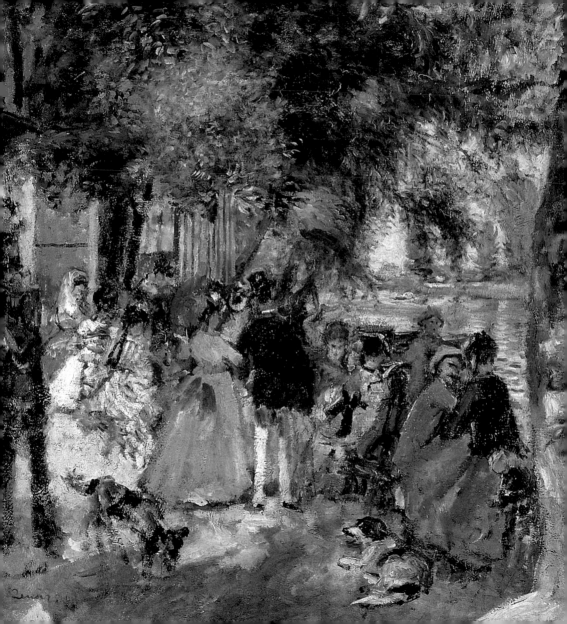

La Grenouillère 1869

23 x 31¼ cm

Oil on canvas

Pushkin Museum, Moscow

Both Renoir and Monet planned to paint large pictures of this popular riverside café and marina, and each prepared several sketches of different areas of the bank and the moorings. In the end, they did not undertake the large canvases, but their sketches are pioneer works, both in their open-air approach and their concentration upon leisure. The conceptions of the two artists differ: whereas Monet was concerned to structure clearly the relation of water, sky, trees, platform, boats, and people, Renoir was more interested in the social scene, in convivial activity and the finery of costumes. The viewer's interest is scattered around his composition, rather than controlled by a firm pictorial organization; but if Renoir's picture is less disciplined, its human interest is greater.

Gust of Wind *c.* 1872

20¼ x 32 in

Oil on canvas

Fitzwilliam Museum, University of Cambridge

Surprisingly, Renoir was one of the few
Impressionists who attempted to register the
effect of breezes upon vegetation: even Degas,
so deeply concerned with human and animal
movement, was barely interested in that of
nature. In this picture, by lively differentiation of
the paint surface, quite thickly impasted in some
areas, thinly glazed and even blurred in others,
Renoir creates a rare instantaneity, a momentary
animation and ruffling of lush nature's calm. By
setting his composition at an oblique angle, the
painter evokes a feeling of rush and excitement,
dramatizing the instant before the cooling breeze
strikes the viewer's face.

43

The Path through the Long Grass *c.* 1876–7

23½ x 28¾ in

Oil on canvas

Musée d'Orsay, Paris

Renoir registers with pleasure the heat of a summer's day and the relaxation of an afternoon walk, from which the strollers are returning. The painting is one of his most successful in combining an appearance of precise recession – we feel we know the position of every tree and bush – with an apparently snapshot immediacy, as the the small figures stroll obliquely towards the painter and home. But the painting is also firmly composed. The poplar tree at the upper centre is directly above the child at the front, accentuating her movement, and the verticals of posts and the trunks of saplings frame the pale earth path running down the picture's center, which in turn sets off the costumes of the figures.

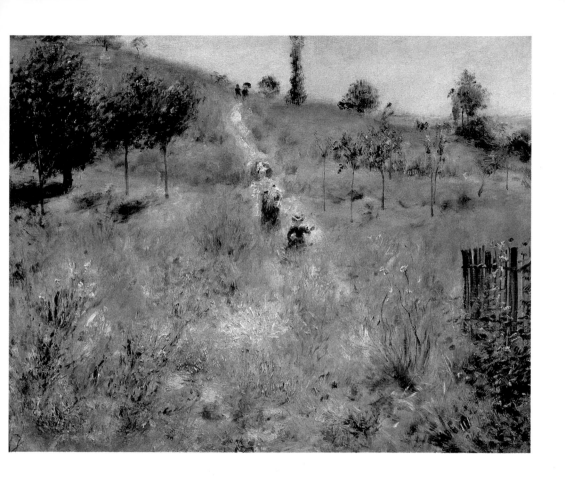

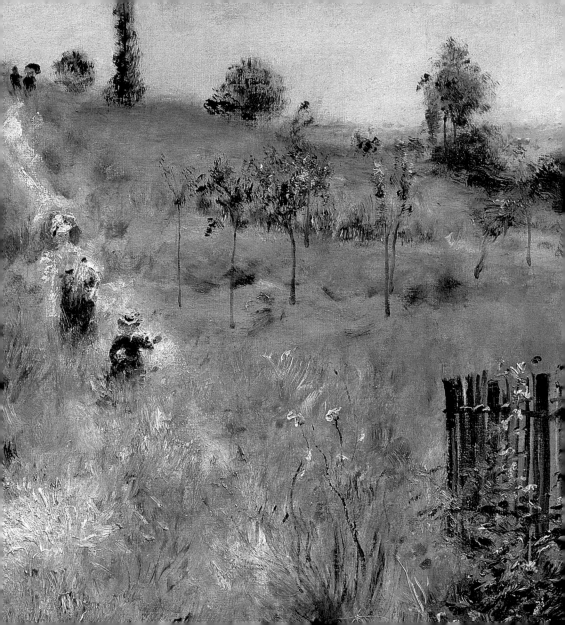

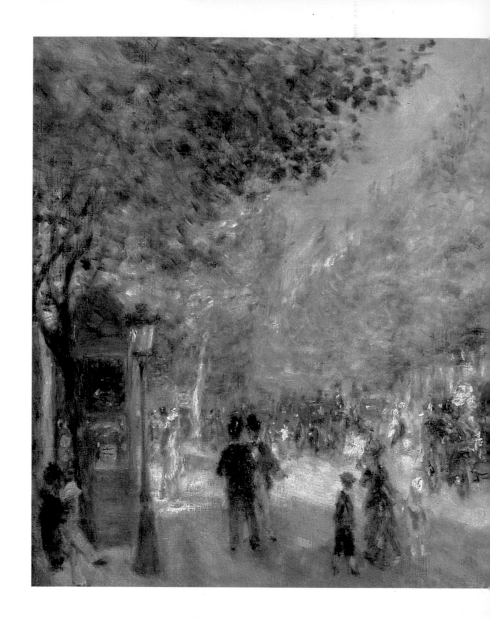

Les Grands Boulevards 1875

19½ x 23¾ in

Oil on canvas

Private Collection

Renoir's choice of subject was probably affected by Monet's two famous views of the Boulevard des Capucines, painted two years before. But whereas Monet viewed the boulevard from a high angle, from a window, Renoir places his easel in the street, among the strollers and shoppers, creating a scene of bustle and vivacity in bright sunlight.

Both Renoir's and Monet's canvases participate in the celebration of Paris that characterized the early years of the Third Republic. Such paintings firmly turned the page on the civil slaughter that had scarred the French capital only five years previously.

The Seine at Argenteuil 1874

20 x 25¼ in

Oil on canvas

Portland Art Museum, Portland, Oregon

Working again with Monet, Renoir painted this view of an area of the Seine that was popular for boating, producing a canvas that resembles very closely a contemporary painting by his friend now in a private collection. However, while Renoir, like Monet, allows the triangles of sails and the diagonal of the jetty to control his design, the overall effect is less geometrical than that of Monet's work. Renoir includes more detail, and pays more attention to the painting's surface, to textures and their interaction, and to reflections. And unlike that of Monet, Renoir's paint application, with unexpected movements of the brush and apparently eccentric emphases, plays against the apparently austere structure of the image.

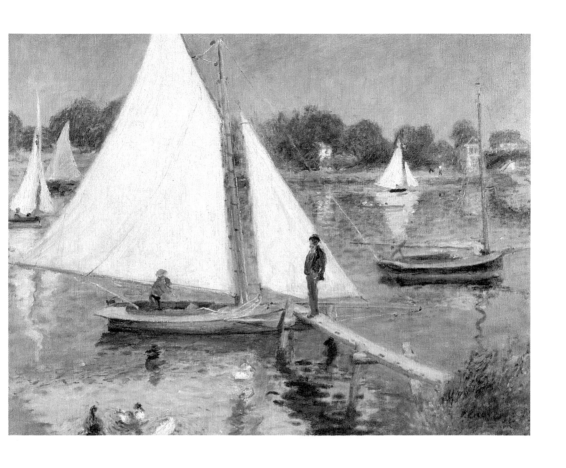

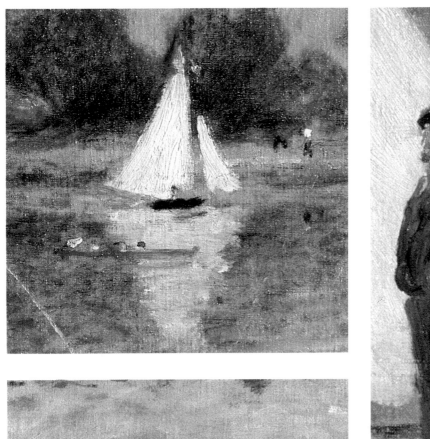

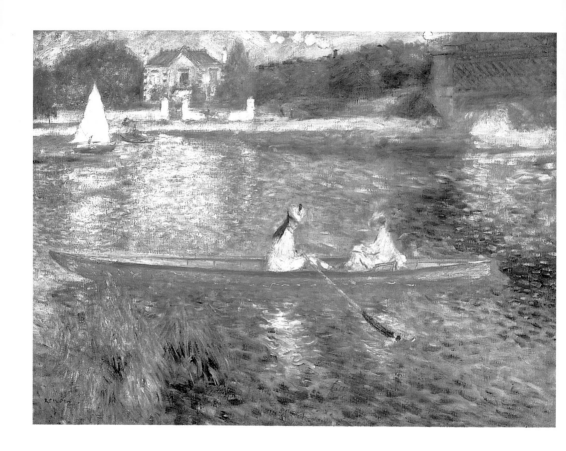

Boating on the Seine *c.* 1879

27³/₄ x 36 in

Oil on canvas

National Gallery, London

All commentators have stressed the extraordinary intensity of
the contrasts between the orange skiff and the bright blue water.
Using such heightened colorism, Renoir seems to push beyond
a record of natural appearances to an evocation of nature's
vigor. In contrast with the preceding painting, this has an
exasperated energy. The water is almost entirely composed of
reflections, and loses substance; the thin skiff makes its way
gingerly, as though its support were uncertain. In this painting,
in a reversal of their usual relation, Renoir anticipates certain
aspects of the later work of Monet: for instance, the latter's
heightened colors of the 1880s and 1890s, and, in his *Lily Ponds*,
the dissolution of water surfaces into webs of reflection.

La Parisienne 1874
62½ x 41¼ in
Oil on canvas
National Museum and Gallery of Wales, Cardiff

Renoir painted this young woman full size, modeling her in an elaborate costume against a blank background and removing her from any identifiable context. In this strategy, there are obvious links with the portrait tradition of the leading French Neoclassical painter Jacques-Louis David (1748–1825), a master of placing his sitters against plain but atmospheric backgrounds. Renoir exploits these associations but avoids the specificity of portraiture. Since we do not know the woman's identity, her alertness, sensitivity, and, probably, shyness are generalized, not specified. She becomes a social type as well as an individual. On another level, the painting is one of Renoir's most consciously 'aesthetic:' a study in the harmonization of blues.

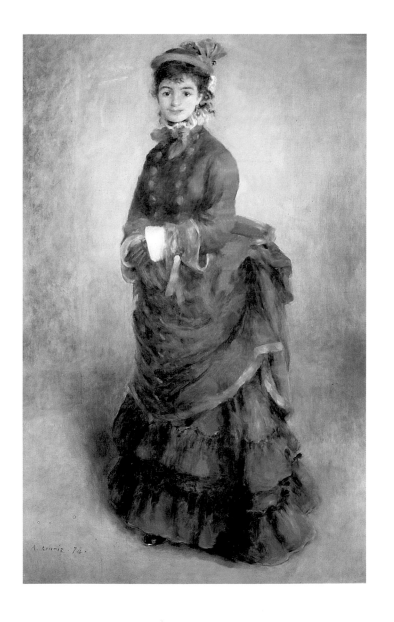

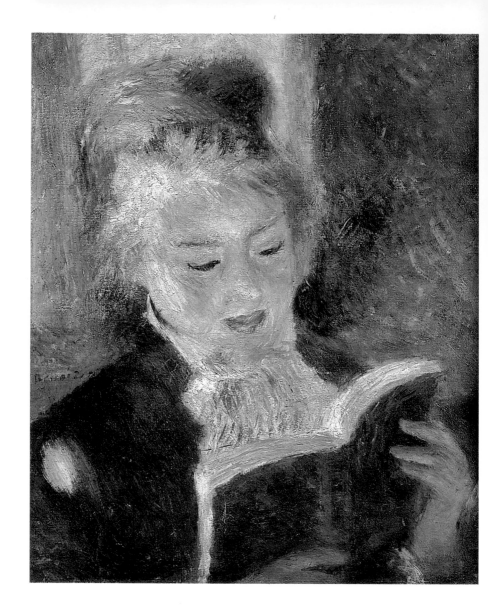

A Young Woman Reading 1874

18 x 15 in

Oil on canvas

Musée d'Orsay, Paris

Renoir concentrates upon his sitter and she concentrates upon her reading. Light falls from the left and is simultaneously thrown up onto her face from the pages of her book, an observed effect and, at the same time, a graceful metaphor for the illumination her reading brings. Treatments of women reading had been a significant theme of French art in the eighteenth century and Renoir's painting reinterprets that tradition, in which intellectual activity is shown as a natural complement of physical charm.

The Box 1874

31¼ x 24½ in

Oil on canvas

Courtauld Institute Galleries, London

One of Renoir's most famous and dazzling images, this painting is made up of a combination of silvery whites and varied blacks that recalls the cavalier portraits of Anthony van Dyck, whose work Renoir greatly admired. But the witty and humane observation of Honoré Daumier (1808–79), a devotee of theatre audiences, is also strongly present. This couple, attending a spectacle, forms a spectacle for Renoir, but they and their finery are not satirized. The man looks around the auditorium with his glasses; the woman has lowered hers, perhaps to respond to a wave from a friend. The off-balance arrangement – the overlapping diamond shapes of the couple – creates a sense of anticipation, of an eagerness for the performance to begin.

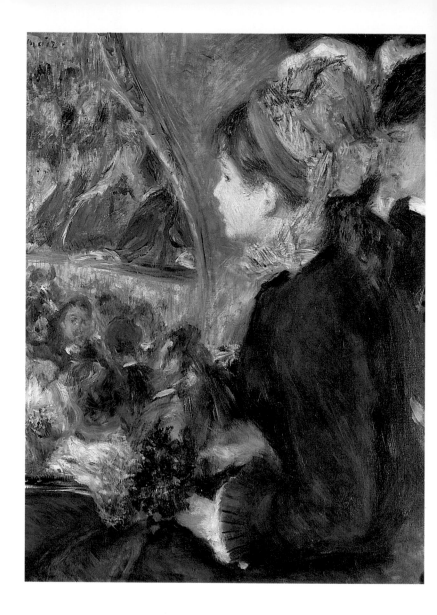

The First Outing 1876–7

25¼ x 19½ in

Oil on canvas

National Gallery, London

In this juxtaposition of near and far, Renoir creates the
vertiginous excitement of a little girl on her first visit to the
theatre, its ambient glitterings and noises not yet classified
and sorted out. Well brought up and lavishly dressed by a
loving parent, she attempts to balance her fascination with
everything around her with a degree of self-restraint. The pose
is caught with a sharpness of observation more readily
associated with Degas – but again the common inspiration is
Daumier, with his visual wit and human generosity. Alone of
the major Impressionists, Renoir was deeply responsive to the
imaginative world of children.

The 1870s

The Swing 1876
36 x 28½ in
Oil on canvas
Musée d'Orsay, Paris

Unusually rectilinear in arrangement for Renoir in its alignment
of vertical forms, this bold composition is softened by the
variegated textures of the young woman's dress and the play
of light and shade over the scene. She stands, swaying gently,
upon the swing, presumably just vacated by the little child on
the left – perhaps her own. It is an idle moment, one of light
conversation. But it surely contains the idea of choice, of some
kind of decision, as the young woman turns her head slightly
away from her interlocutor. Renoir was deeply fascinated at this
time by effects of dappling: in addition to spreading patches of
sunlight and shadow over the clothes and the ground, he sets in
flight seven blue butterfly bows that ascend the woman's dress.

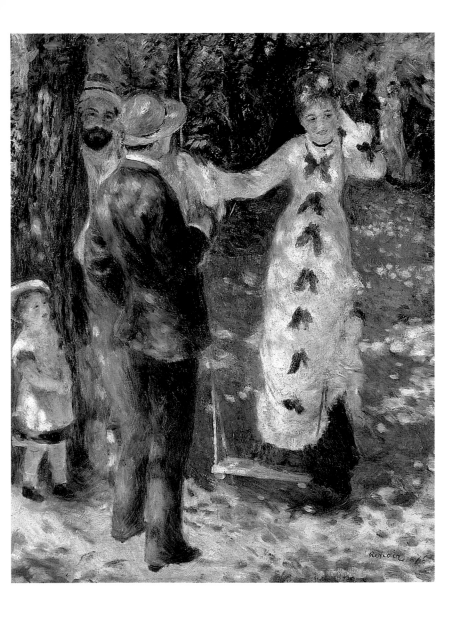

Ball at the Moulin de la Galette 1876

51 x 68¼ in

Oil on canvas

Musée d'Orsay, Paris

This was Renoir's most ambitious painting hitherto. In the
bright sunshine of a Parisian summer, a group of young men
and women are conversing and dancing. They are probably
shop-workers or artisans, yet for Renoir they are both classless
and civilized. Emotional attachments and courtship are implied,
perhaps, but not stated. The stretch is panoramic, although the
artist, while by no means a participant, is not remote from the
scene. Partly by differentiated focus, Renoir achieves a sense of
movement inwards, as though his camera were tracking towards
the group. But however much he may have been with them in
spirit, Renoir could no longer join this group: his painting is an
evocation of the life of 20-year-olds by a man who was now 36.

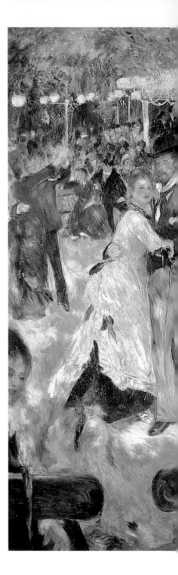

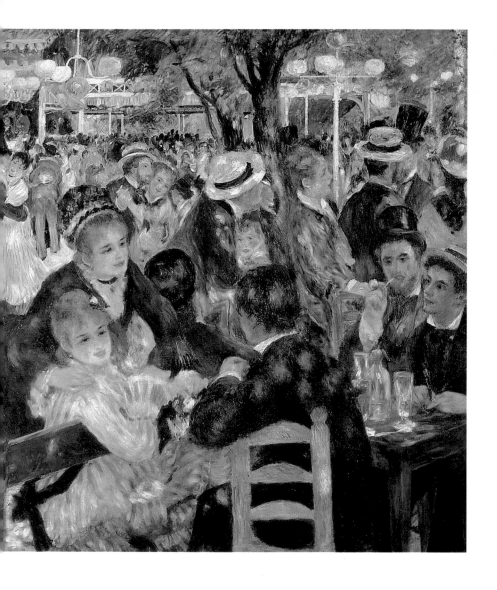

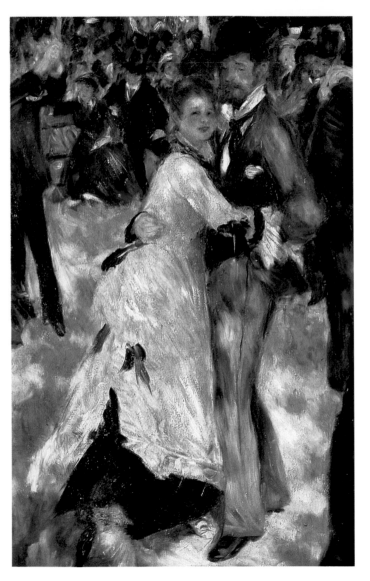

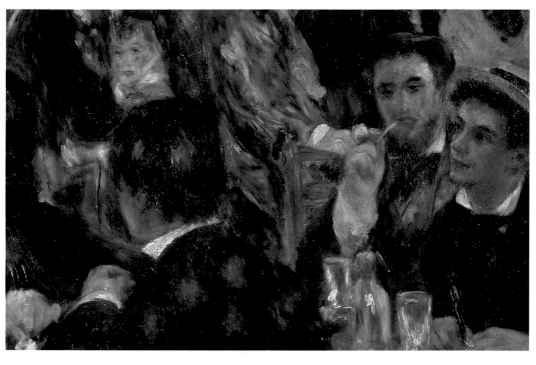

Nude in Sunlight 1875

31½ x 25¼ in

Oil on canvas

Musée d'Orsay, Paris

Among the most famous of Renoir's paintings, this is one of a relatively limited number of nudes that he painted in the 1870s. Unlike the nudes of the later period, this figure is placed within – almost submerged by – dense verdure, through which patches of light filter onto her skin. Renoir was tackling an extremely difficult technical problem, and although to modern eyes he was entirely successful, some contemporary critics felt that the solidity of her flesh and the sheen of her skin were decomposed by the patches of color denoting light and shade.

Structure and atmosphere are balanced with a certain breathlessness and excitement: although overt mythical associations are absent, it is difficult to exclude the possibility that she is a nymph, the spirit of the place.

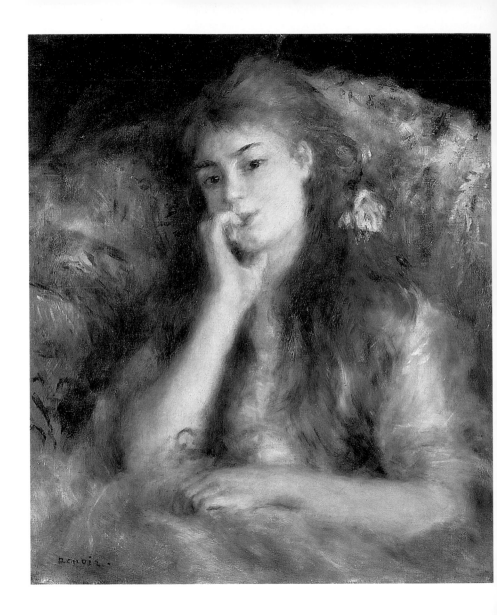

A Young Woman Seated *c.* 1876–7

25³⁄₄ x 21¹⁄₂ in

Oil on canvas

Barber Institute of Fine Arts, Birmingham

Although Renoir disliked the title that this study of a seated young woman subsequently acquired, *La Pensée* (*Thought*), it is not wholly inappropriate, for although his model is seen in repose, it is evident that her mind is active. Renoir probably conceived the work mainly as a study in the relation of skin, hair, and thin, partly transparent fabrics under firelight, an indoor version of his 'dappled' manner of the previous couple of years. It is among his most evanescent of paintings, composed of superimposed films of thin pigment, with the denser forms seeming only marginally more substantial than gauze.

Madame Charpentier and her Children 1878

60 x 74 in

Oil on canvas

Metropolitan Museum of Art, New York

This composition is unusual as a treatment of a mother and her children. Renoir has secularized an arrangement found in some seventeenth-century renderings of the Virgin with Child and St John, notably by Rubens and his followers. A splendidly furry dog substitutes for St John's lamb. Another seventeenth-century feature is the amplitude of forms and the glistening fabrics, obtained by a succession of glazes, which conjure up the luxuriance of van Dyck's work. The interior setting, without natural illumination, allows Renoir to play up a vast range of different surfaces and textures that interrelate without any loss of precision: the scene shimmers and glistens.

In 1908 this became the first painting by Renoir to be bought, at a very high price, by the Metropolitan Museum. It is no coincidence that this was the period in which Americans were fascinated by the neo-van Dyckian style of John Singer Sargent.

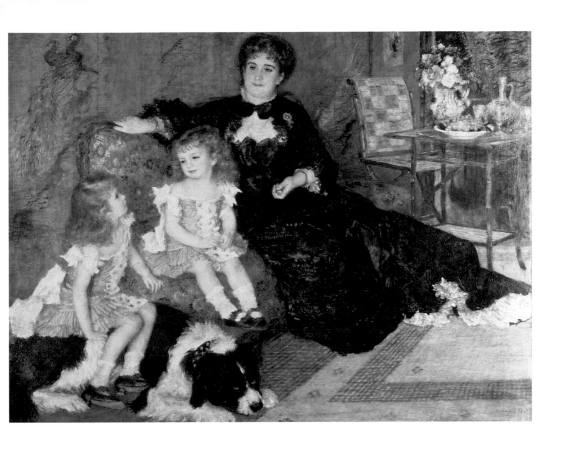

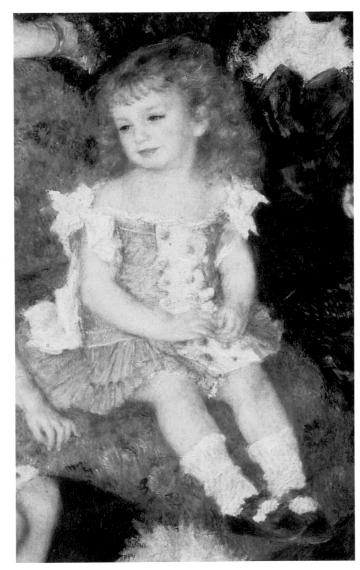

The 1880s

PAINTINGS BETWEEN 1880 AND 1889

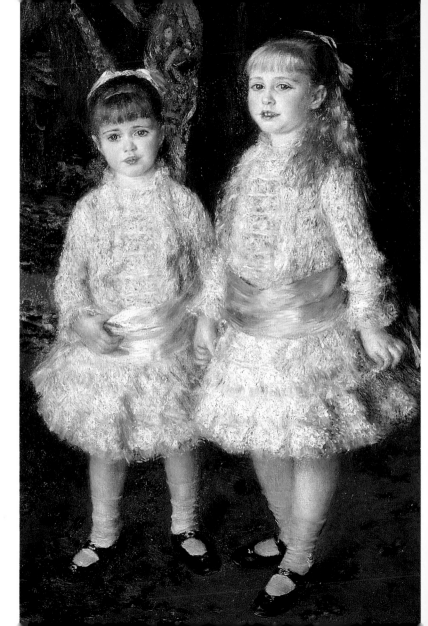

The Cahen d'Anvers Girls 1881

46½ x 28¾ in

Oil on canvas

Museu de Arte de São Paolo 'Assis Chateaubriand'

São Paolo, Brazil

This double portrait in pinks and blues of two little girls, the elder aged seven, the younger aged five, was disliked by the family that commissioned it. It is difficult to imagine why. It is a fairy-tale, fancy-dress painting of extreme technical proficiency, displaying a dazzling variety of textures and colors. Again Renoir turned to seventeenth-century art for his model, here to Velázquez.

Renoir must have been charmed by the children and he set out to create an image that was beautiful, like a bouquet of flowers. The girls are aware of the painter's game and enter into it. Their self-consciousness eliminates what could have been cloying; and Renoir suggests that they are on stage by viewing them from an angle slightly higher than one would expect, as though from a box.

The Place Clichy c. 1880

25¼ x 21 in

Oil on canvas

Fitzwilliam Museum, University of Cambridge

In the novel technique of striated brushstrokes that build
up the woman's hat and costume, this painting displays an
experimentalism that characterizes much of Renoir's work
around 1880, when he was concerned to give his figures greater
solidity. Although there are some similarities in composition with
The First Outing (see page 62), the intrusion of the young
woman's head remains surprisingly bold. Degas's influence is
often suggested, but he painted nothing quite like this. The
woman is in sharp focus, and the crowd in the Place Clichy
blurs around her: in this way Renoir anticipated one of the key
themes of Futurism. But Renoir's painting is not a demonstration
of the interaction of city life and the individual psyche: rather it is
a moment observed, as a lively young woman moves across a
crowded place.

Alphonsine Fournaise at la Grenouillère 1879

28¾ x 36¼ in

Oil on canvas

Musée d'Orsay, Paris

In this study of a vivacious young woman seated at the corner of a table, on a balcony overlooking the river, Renoir seems to have gone about as far as he could in the merging of near and far, figure and environment. The great painting of the *Luncheon of the Boating Party* (*see pages 86 and 88–9*), which he painted over the next two years, represents a reaction against this, towards more solid form. But despite this painting's softness of texture and lack of strong accents, it is more structured than it seems. The edge of the table and the railing against which Alphonsine rests her right arm meet somewhere behind her right breast, which is also where the strongest light falls. Renoir thus wittily superimposes the protrusion of Alphonsine's form upon the recession of the objects around her.

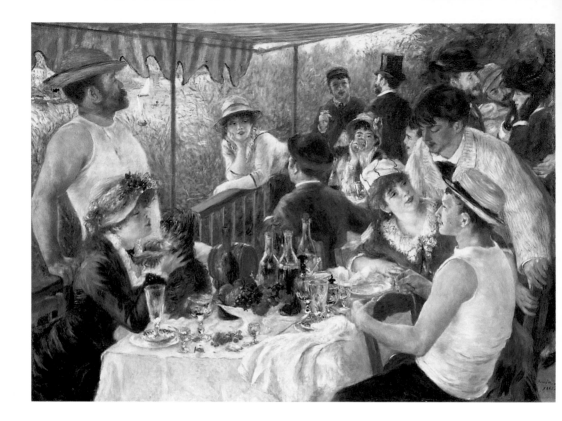

Luncheon of the Boating Party 1880–81

50³/₄ x 67¹/₂ in

Oil on canvas

Phillips Collection, Washington, DC

This is among Renoir's most ambitious and complex paintings. Unlike the *Ball at the Moulin de la Galette* (*see pages 66–7*), he chose a low, narrow-angle, deep-focus view, like a photograph with a long exposure. The position is that of a participant in this relaxed luncheon, in which most of the others are seen at half-length, not the panoramic survey of an observer.

The considerable difficulties of organization, both of surface and depth, are in part solved by the employment of verticals – the supports of the awning – and horizontals – the table and the railing. These simultaneously divide the canvas and hold it together. One vertical bisects the canvas: to the left, Renoir places only three figures; to the right, eleven. This helps create a convincing sense of relaxation at the end of a meal, as the group breaks up, the diners beginning to get to their feet and stretch their legs.

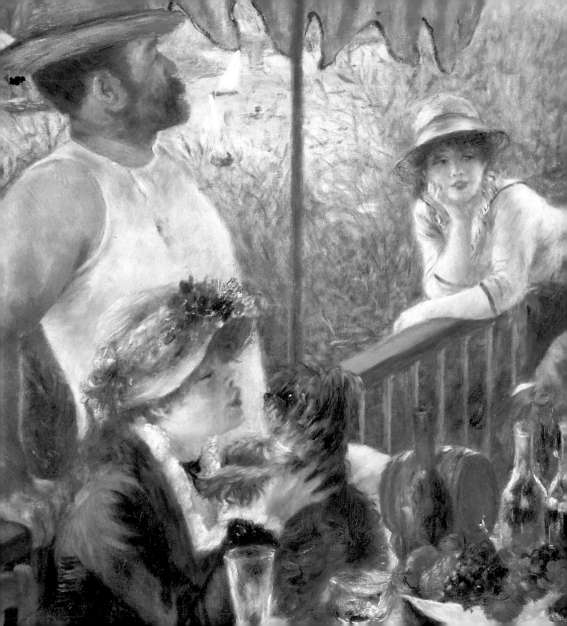

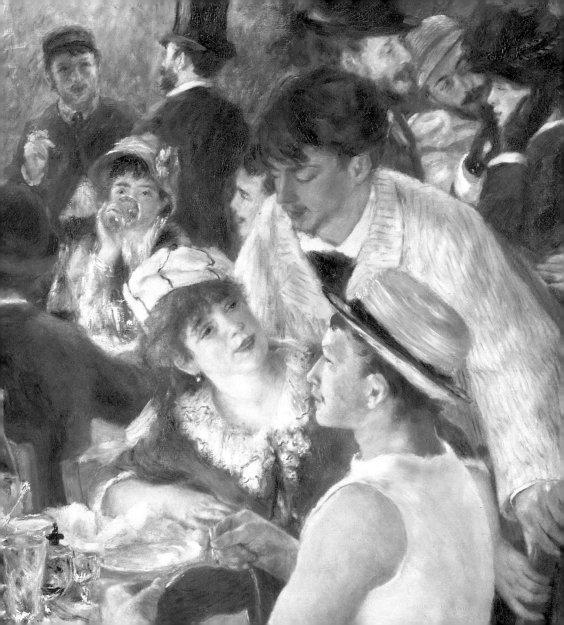

The Two Sisters 1881

39 x 31¼ in

Oil on canvas

Art Institute of Chicago, Illinois

Although tighter in surface and denser in modeling than the picture of Alphonsine Fournaise (*see pages 84–5*), which it resembles by setting its figures against the river, this painting is comparable with *The Cahen d'Anvers Girls* (*see page 80*) in its flowery appearance. But as well as charming the eye Renoir has also set out a little fugue on the idea of spring. The field behind the sisters is bursting with flowers, their basket is filled with flowers, the small girl wears flowers in her hair, and her older sister sports flowers on her dress. Both are in their own springtime, one of childhood, the other of young womanhood. And against this abundant flowering Renoir plays the bright red of the hat: artifice outshining nature.

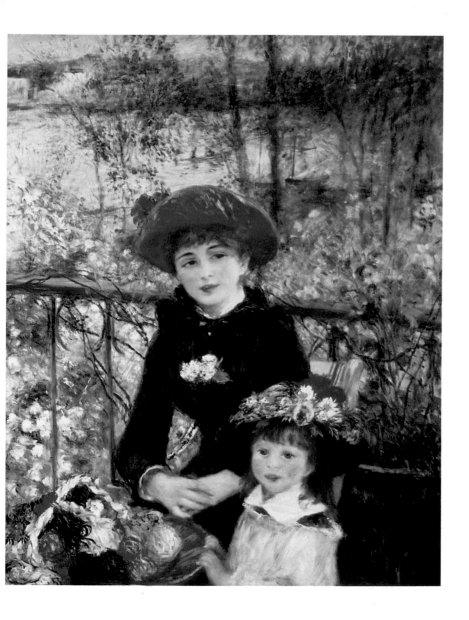

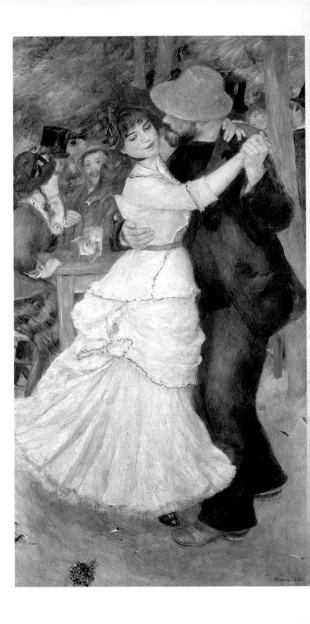

Dance at Bougival 1882–83

71 x 38¼ in

Oil on canvas

Museum of Fine Arts, Boston, Massachusetts

This is one of Renoir's rare paintings after the 1860s in which he conveys a real sense of erotic intensity. Here it is evoked in the whirling movement of the dancers and the physical energy of the man, who clasps his partner ardently. She turns her face away and looks down. The angle of her head matches her swinging skirt: both respond to the rhythm of the music. While it seems to be a picture of courtship, the woman's engagement ring implies that a commitment has already been made.

Her red bonnet, set against the man's yellow straw hat and his loose blue suit, streams like a flag. It heats the painting, adding an excitement of color to that of movement. Although the class of the couple is not certain, they seem more bohemian – perhaps an artist and a model – than proletarian.

Dance in the Country 1882–83

70¼ x 35 in

Oil on canvas

Musée d'Orsay, Paris

The couple in this painting could be two of the figures from the
Moulin de la Galette a few years on. More subdued than the
Dance at Bougival – although the man has lost his hat – it
nevertheless is more casual than its pendant, *Dance in the City*
(*see page 96*). It also evokes a real sense of fun: the woman
is giggling at the lost hat, and her fan, spread behind her
husband's (?) head, provides a jokey substitute for it. This couple
are surely members of the *petite bourgeoisie* and older than
those in the companion paintings – they may be reviving
memories of more energetic dances.

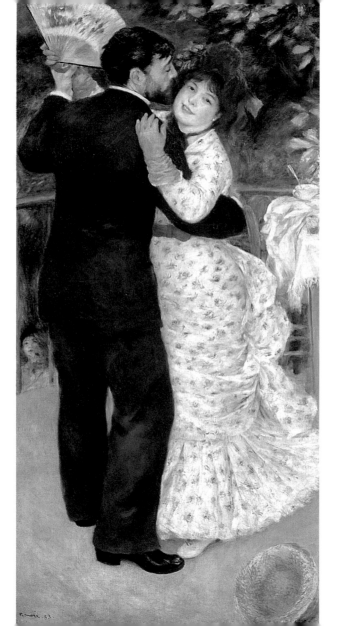

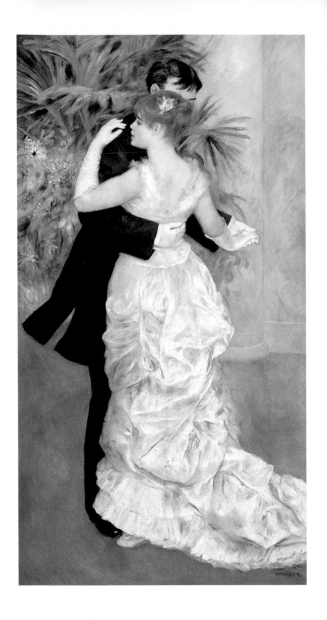

Dance in the City 1882–83

70¼ x 35 in

Oil on canvas

Musée d'Orsay, Paris

Some critics tend to assume that whenever the *bourgeoisie* is
depicted the artist's intention is, or should be, critical. But
criticism, still less satire, seems to have been far from Renoir's
intention here. The couple is clearly from the *haute bourgeoisie*
and their dance is decorous – both partners wear gloves – but
there is no sense that this is an 'arranged match.' The woman
dominates, obscuring the face of her partner, her silvery dress
shining against his suit. If the relation between the Bougival
dancers is likely to be tempestuous, this voyage of love looks
as though it will encounter quieter seas.

The encapsulation of varied lifestyles and different classes
in Renoir's three images of couples dancing is an impressive
achievement, and the series stands among the most resolved
of the artist's 'social' studies of contemporary life.

The Umbrellas c. 1881 and c. 1885

70¼ x 44¾ in

Oil on canvas

National Gallery, London

Although Renoir executed paintings in both harder and softer styles simultaneously in the early 1880s, this is a rare example in which the two manners coexist. The figures on the right-hand side of the painting are executed softly and atmospherically, but the umbrellas and, especially, the costume of the young woman on the left are painted in a harder, more constructed manner, one partly influenced by Cézanne; her skin is also given a denser, more porcelain texture.

Renoir did not explain why he chose to juxtapose older and newer manners in this, the last of his large modern-life subjects, rather than simply overpaint the earlier work. But it may have been because the juxtaposition creates an effect like that of *The Place Clichy* (*see page 83*): a young woman isolated for a moment in a crowd.

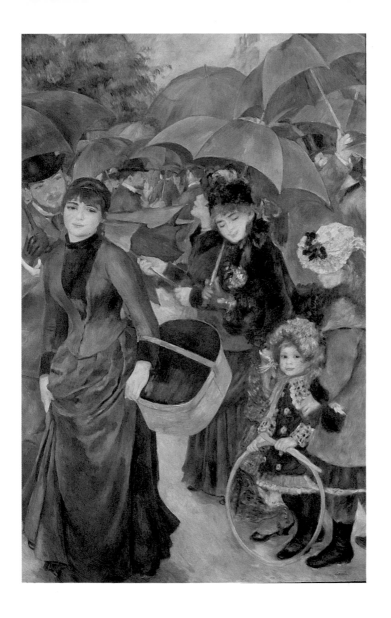

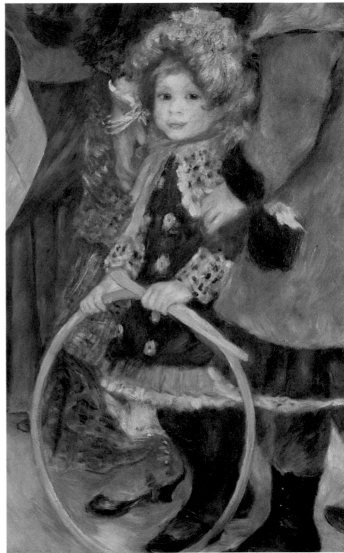

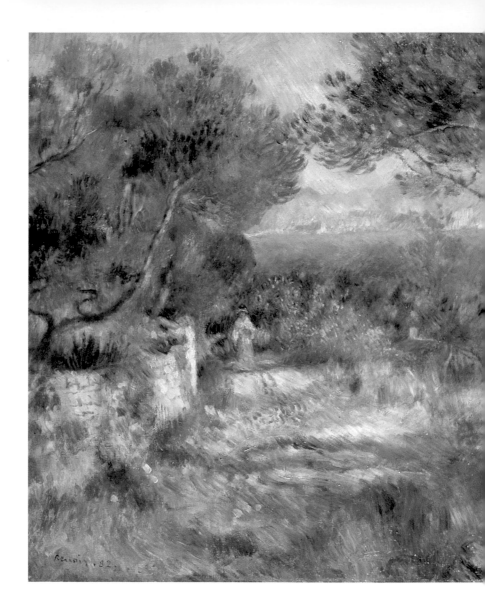

L'Estaque 1882

25¾ x 32 in

Oil on canvas

Galerie Daniel Malingue, Paris

In 1881 and 1882 Renoir travelled to North Africa, and then on to Italy. Upon his return to France in January 1882 he stayed at L'Estaque in the south of the country and painted for a time with Cézanne, who exploited this site intensively. These years marked Renoir's first extended experience of Mediterranean light and climate, as well as of Italian art. His colors now became hotter and more intense. Here, the olive greens of the arching trees set off and frame the vivid blue of the sea and the warm light of the town in the center background. This tightly composed interrelation of buildings, sea, and vegetation is heavily dependent on the work of Cézanne, who henceforth becomes an important influence upon Renoir.

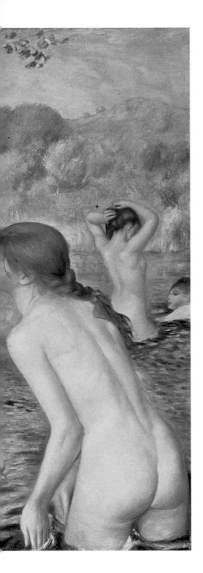

The Bathers 1887

44¼ x 66¼ in

Oil on canvas

Philadelphia Museum of Art, Philadelphia, Pennsylvania

Renoir worked on this large painting over several years. His aim was to create more solid form than he had done previously. Unlike the *Nude* of 1876 (*see page 71*), these bodies are clean-cut, sculptural, and hard edged. And although the landscape plays a considerable part – treated in a 'structural' manner that owes much to Cézanne – it is a relatively flat background and does not envelop the figures: bodies are more important than setting.

The composition is abbreviated from a seventeenth-century relief sculpture by François Girardon, made for a fountain in the gardens of the Palace of Versailles. In this relief, movements and gestures suggest the myth of Diana and Actaeon, though no huntsman is present and none of the nymphs is identified as a goddess. Renoir reduces the narrative content yet further by taking only three figures from Girardon's composition. Instead of describing action, Renoir provides a grandiose and ample vision of woman and nature.

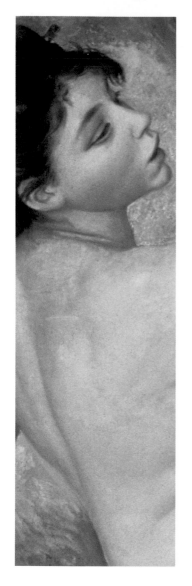
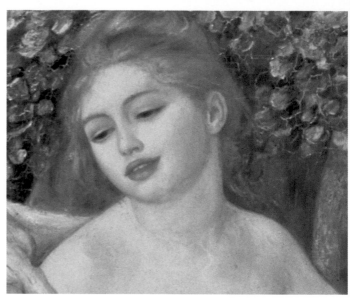

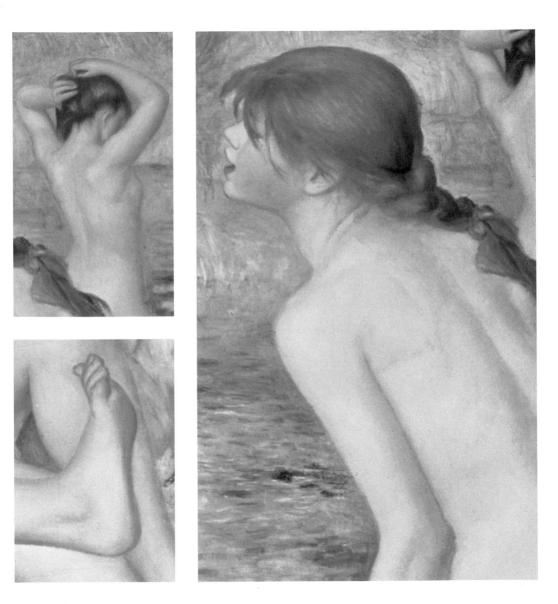

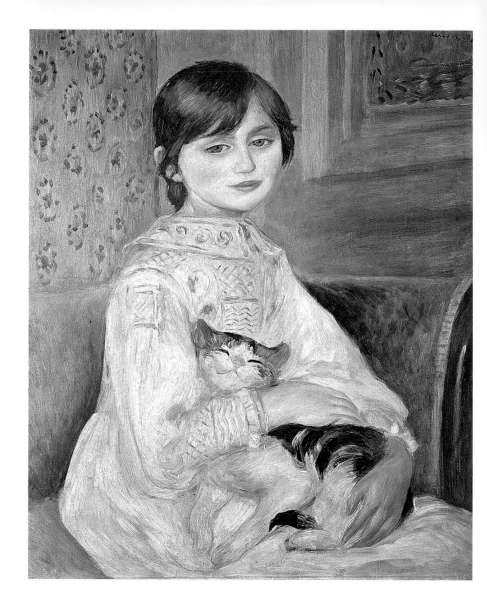

Julie Manet with Cat 1887

25¼ x 21 in

Oil on canvas

Private Collection

Renoir was a friend of the Impressionist painter Berthe Morisot (1841–95), who was married to the brother of Édouard Manet. There are frequent references to Renoir in the diary of their daughter Julie, and it is clear that he was very fond of her. He remained close to the family after Berthe's death.

This portrait, whose surface is quite tight and hard, demonstrates Renoir's simplified style of the 1880s and his devotion to high-key coloring, like that of the Italian frescoes he had come to admire: in 1910 he wrote a preface to a translation of the painting manual by the late-fourteenth-century artist Cennino Cennini. Here, in fact, the arrangement is slyly dependent upon Raphael's *Madonna della Sedia*, which had greatly impressed Renoir when he saw it in Italy in 1881. He has simplified Julie's face drastically in his desire to create a geometrical purity, but this does not detract from her liveliness and charm, especially since her face rhymes with her cat's.

The Late Paintings

PAINTINGS BETWEEN 1890 AND 1919

A Bather c. 1890

15¼ x 11¼ in

Oil on canvas

National Gallery, London

Renoir produced many small paintings of female nudes in the open air during the latter part of his career, and they found a ready market. In this he was following a trend that had been particularly established by Jean-Baptiste-Camille Corot (1796–1815) in the 1850s and 1860s. In the work of both painters the freshness of young women is equated with the freshness of nature – an implied but unforced allegory. The present painting is, however, more solid and sculptural than most of Renoir's works of this type, and relatively unusual in that it shows the model's back. Despite the small scale, the form has a grandeur that anticipates the work of the French sculptor Aristide Maillol, whom Renoir came to admire intensely. Maillol's influence on the late Renoir is often stressed, but it is likely that the sculptor's own development was also reciprocally affected by his knowledge of Renoir.

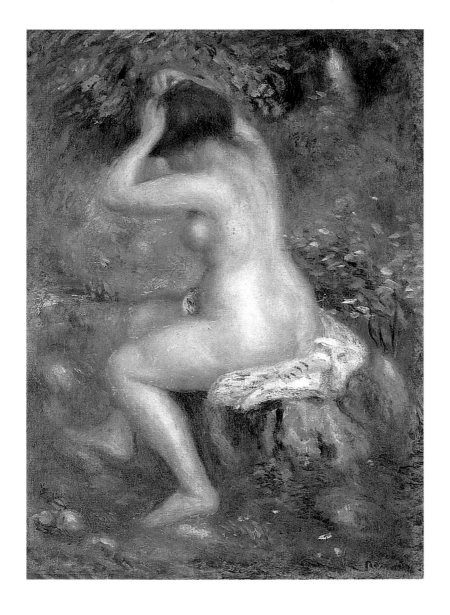

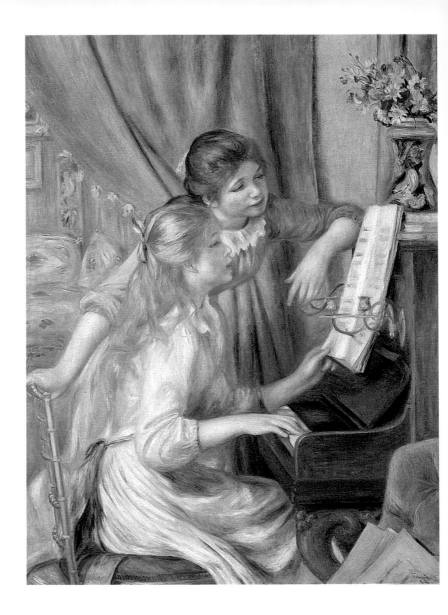

Young Girls at the Piano 1892

45¼ x 35 in

Oil on canvas

Musée d'Orsay, Paris

This work was acquired by the French state, in the year it was
painted, for the gallery of living artists, the Musée du Luxembourg
in Paris. The purchase, strongly promoted by Renoir's close
friend the poet Stéphane Mallarmé, marked the beginning of
official acknowledgment of Renoir's achievement, which had
been withheld for nearly 30 years. Although it was not strictly a
commission, Renoir knew that the state wished to make a
purchase and, in his anxiety, painted five versions of equal size;
later he concluded that the state had not the bought the best. But
this painting is the grandest, simplest, and most tightly organized
of the series; a simple domestic scene of two teenage girls at the
piano – one playing, the other turning the pages of the score – is
imbued with an imposing seriousness. In this version, Renoir
resisted the temptation to pattern and prettify the costumes,
and the result is among his most coherent figure compositions.

Yvonne and Christine Lerolle at the Piano 1897

28½ x 36 in

Oil on canvas

Musée de l'Orangerie, Paris

Although similar in motif to his work of 1892 (*see page 114*),
this scene is painted from a slightly closer viewpoint, and the
composition and color are more severe. The two daughters of
Renoir's friends, the Lerolles, are practicing, but the elder, clearly
more advanced, is instructing the younger. Renoir probably
chose a horizontal composition so that he could include two
paintings by Degas that the family owned, showing scenes of
the races and the ballet, between which the girls' heads are
displayed. Renoir is obviously acknowledging the influence of
Degas, a master of this kind of arrangement. There is also
a reference to Whistler's famous *At the Piano* of 1859 (Taft
Museum, Cincinnati, Ohio), which makes similar use of framed
pictures to articulate the composition. But Renoir's painting is
also confident, a statement of difference from his prototypes.

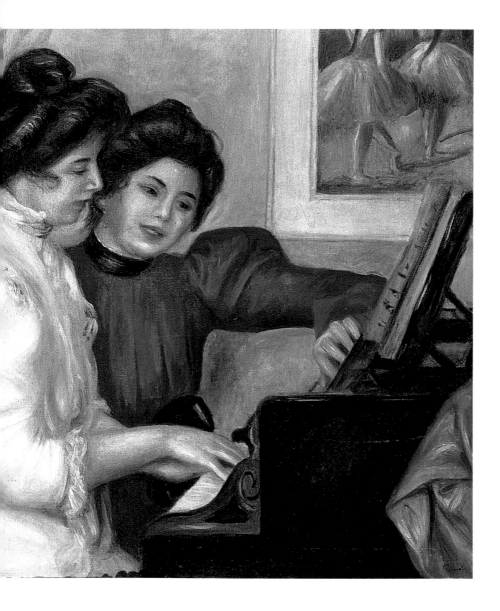

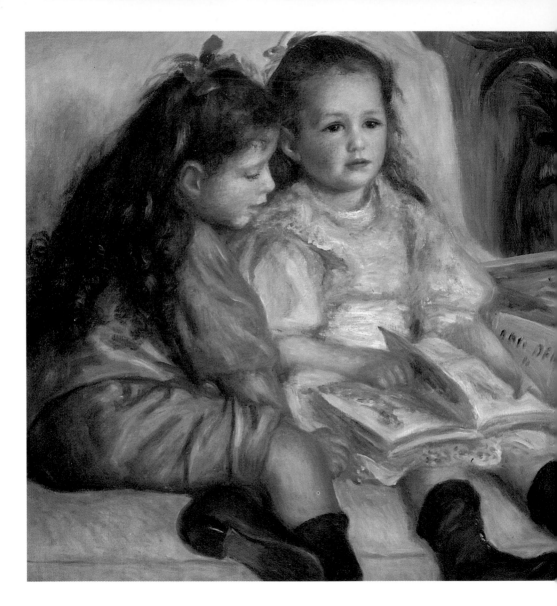

The Children of Martial Caillebotte 1895

25¼ x 32 in
Oil on canvas
Private Collection

Martial Caillebotte was the brother of Renoir's friend Gustave Caillebotte (1848–94), the great collector of Impressionism and himself a considerable artist. When Gustave died, he bequeathed his entire collection to the French state. It was the first major grouping of Impressionist paintings to become public property and it formed the nucleus of what is now the collection of the Musée d'Orsay.

Complex negotiations were required to obtain artists' acceptance of the bequest and during these Martial, too, became a friend of the painter. Renoir's double portrait of his two daughters, framed at one side of a sofa, is restrained and densely modeled. Books are again the focus of attention, and the seriousness of these two little personalities is caught with warmth and sympathy.

The Late Paintings

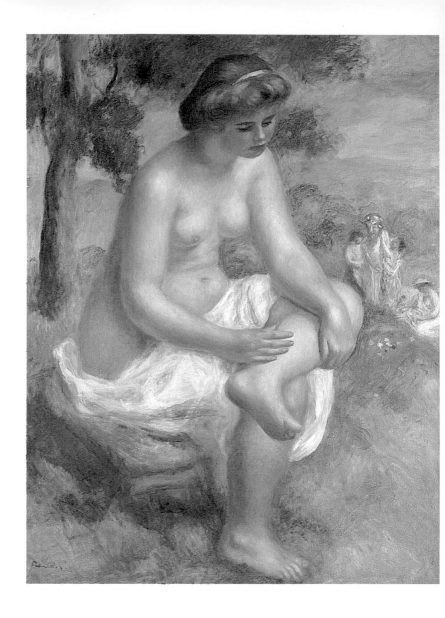

Seated Bather, or Eurydice c. 1900

45¼ x 34¾ in

Oil on canvas

Musée Picasso, Paris

In this work Renoir arranges his figure in a pose invented by
Raphael, but sets her at an oblique angle, in obvious imitation of
sculpture, a medium also suggested by the texture of her flesh.
Although not a direct illustration of the mythical story of Eurydice,
who was snatched from her husband Orpheus by an adder's
bite, the suggestion that she may be examining a wound on her
foot evokes that subject.

Sometimes, as in his two versions of *The Judgment of Paris*,
which were loosely based on a composition by Rubens, Renoir
illustrated myth directly. However, open-ended treatments
alluding to classical myths without illustrating them directly, are
more characteristic of his late work. He drew strength from
tradition without confining himself in it. This aspect of his work
was much exploited in the 1920s by Picasso, who owned
the painting.

Seated Bather *c*. 1903

36 x 28½ in

Oil on canvas

Kunsthistorisches Museum, Vienna

With her small head and ample body spread out across the
picture plane, this painting is emblematic of much of Renoir's
work after 1900. The woman's action, simultaneously drying her
hair and legs, is no more than a pretext for extending her limbs
to the corners of the picture. The sequence of near – but never
exact – diagonals from which the body is built up gives the
arrangement a clarity that takes this painting out of the realm of
a mere study, whilst retaining a casualness that prevents the
image becoming posed and stiff.

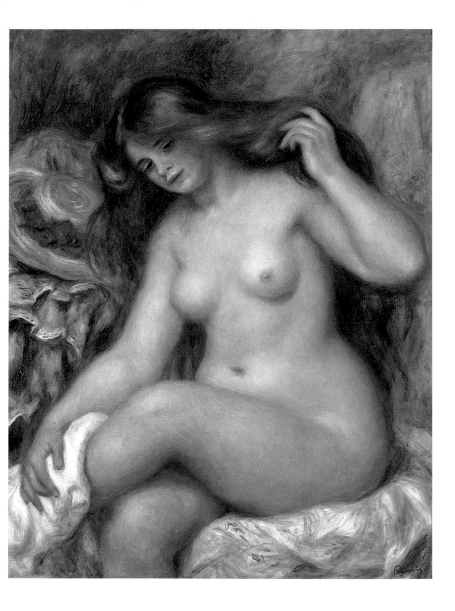

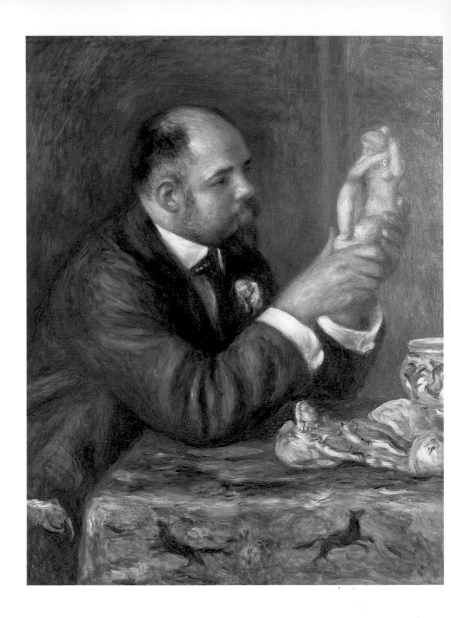

Portrait of Ambroise Vollard 1908

32 x 25¼ in

Oil on canvas

Courtauld Institute Galleries, London

In this portrait of his dealer and biographer Ambroise Vollard, who – not coincidentally – was also an important promoter of the young Picasso, Renoir has evoked Vollard's sensual passion for works of art. Set against the imprecisely measured corner of a red-walled room, Vollard weighs in his hands and caresses with his eyes a statuette by Aristide Maillol, a monumental nude in miniature, and has laid aside a pigmented oriental figurine, recumbent on the table. As well as suggesting other areas of Vollard's activity, Renoir may also be evoking his own history, his passage from china painter to creator of grand classical nudes. The red-hot setting brings out the greens in the tapestry that covers the table, on which can be made out the silhouettes of hunting dogs. Seen in relation to the statue, they perhaps suggest one of Diana's hunts.

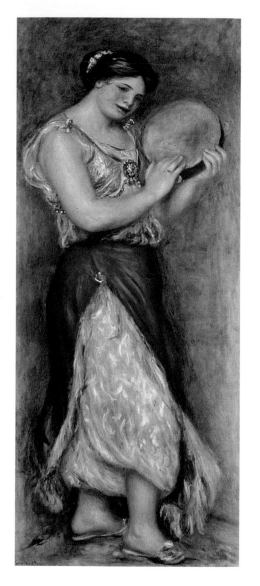

Dancer with Tambourine 1909

60½ x 25¼ in

Oil on canvas

National Gallery, London

With its pair, *Dancer with Castanets* (*see opposite*),
this canvas was painted as part of a decorative
scheme for the dining room of the Paris apartment
of Renoir's friend Maurice Gangat. The two
paintings were placed on either side of a fireplace.
Initially, the two women were planned to be carrying
bowls of fruit, like allegories of the seasons, but
Renoir changed the subject to dancers playing
simple percussion instruments. Music was a
permanent interest of Renoir's and a continuing
theme in his work, but he may also have felt that the
inclusion of fruits, with their varied colors, would
break up the relative simplicity and grandeur of form
appropriate to a mural decoration.

Dancer with Castanets 1909

60½ x 25¼ in

Oil on canvas

National Gallery, London

Like her companion, the dancer with castanets fills
virtually the entire space available. Both figures
stretch out across the plane of the canvas like forms
carved in low relief and Renoir may have found
inspiration in sculpture, in which he was becoming
increasingly interested. He had, in 1907, executed a
medallion in plaster of his youngest son Claude.
While making great play with shallow folds and
ridges of drapery in order to create patterns across
the paintings, he reduces detail. He also restrains
color. The tambourine dancer wears a red
overskirt, while the castanet dancer sports a blue
sash; and although elements of these colors
are exchanged, linking the two works, the effect is
a complementarity of form and mood rather than a
repetition, with mobility in one set against stasis in
the other.

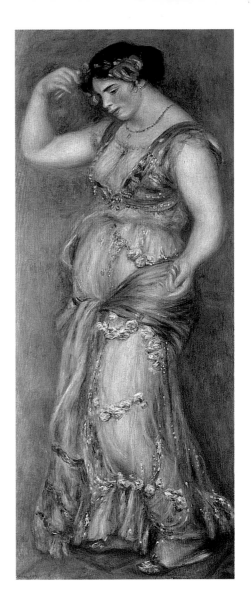

Claude Renoir in a Clown's Costume 1909

46¼ x 30 in

Oil on canvas

Musée de l'Orangerie, Paris

In this portrait of his youngest son, born in 1901, when Renoir was 60 years old, the painter has stressed the simple shape of the bulbous costume and its intense, unvaried red. This gives the boy a surprising bulk and authority, although one that is in part playful, given that the costume is a clown's. The oblique placement of the columns on the right – a device found frequently in seventeenth-century portraiture – suggests that Claude is moving forward, emerging into a realization of his own personality. All three of Renoir's sons were to enter the performing arts: Claude became a great motion-picture photographer, whose work in color was particularly innovative.

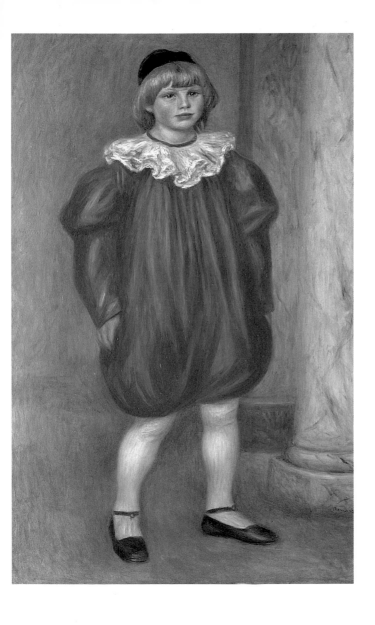

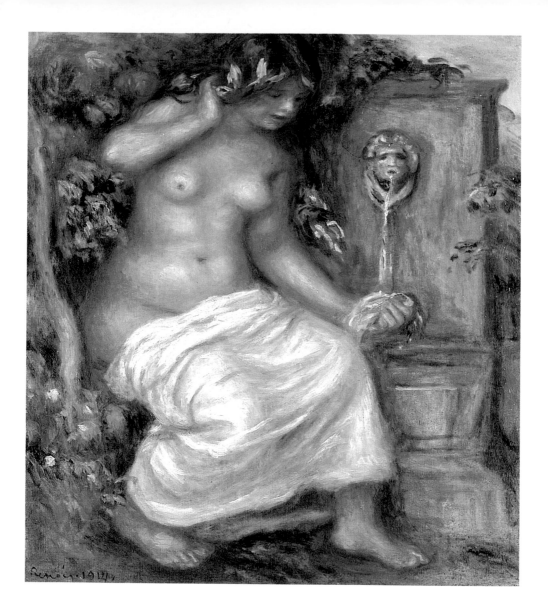

The Bather at the Fountain 1914

21½ x 18¼ in

Oil on canvas

Private Collection

Most of Renoir's late studies of the nude eschew precise context. Here, however, the fountain is clearly described and plays an important role. Both drapery and setting clearly indicate that Renoir was focusing on another aspect of tradition, that represented by the seventeenth-century French artist Nicolas Poussin (1594–1665), whose work was increasingly finding favor among younger artists in this period. The slight stiffness of the figure, the angular draperies and the tightly geometrical composition were central to Poussin's later mythologies.

Different sections of the figure are seen from different angles, and there is also some disproportion among the parts. This should not be ascribed to the incapacity of an old man. It was noted within a year or two of Renoir's death that part of his late experimentalism was precisely to combine different views: this gives the spectator a novel sense of the familiar. It is tempting to suppose that Renoir may have absorbed, if only through osmosis, something of Cubism, which had recently been invented by Picasso and Georges Braque.

The Saône flowing into the Arms of the Rhône 1915

36 x 29 in

Oil on canvas

Private Collection

The personification of rivers was an antique formula, exploited in the Renaissance and Baroque periods. Renoir's sketch, made as a tapestry design, is a deliberate revival of this pictorial tradition, especially as treated by Rubens – above all in his Marie de' Médicis cycle now in the Louvre, much admired by Renoir – and by Charles Lebrun (1619–90). Both gave their allegorical figures the energy and allure of living actors, and their example inspired Renoir to do the same.

While the painting of grand allegory, as such, was new to Renoir, its occurrence so late in his life marks one more return to the interests of his youth, specifically in Delacroix, the nineteenth-century French painter who most successfully revived the form. Indeed, Renoir's sketch bears more than a passing resemblance to Delacroix's late unfinished *Allegories of the Seasons*, which he would have known from their passage through the shop of his dealer Paul Durand-Ruel.

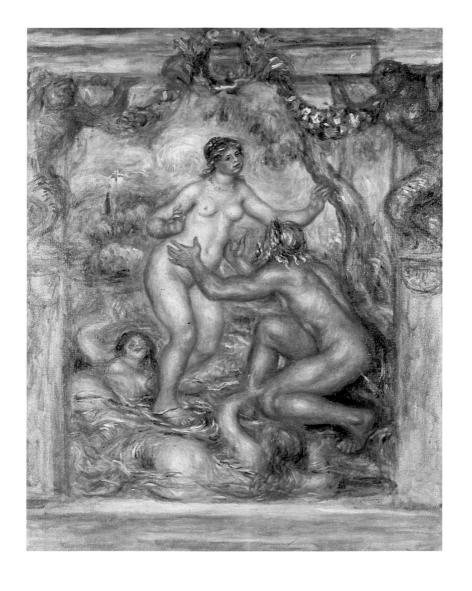

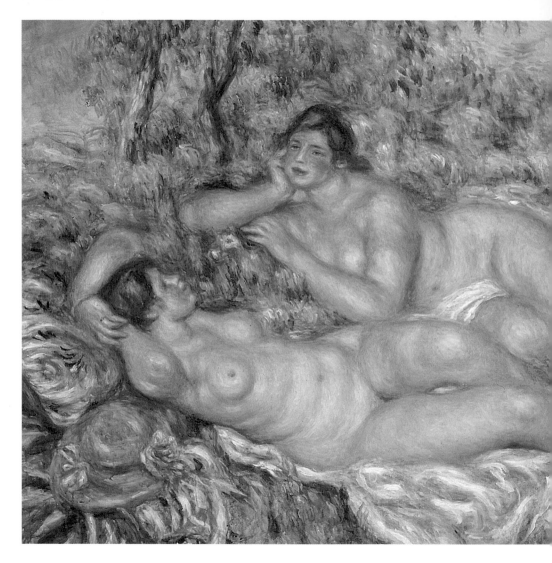

Large Bathers 1918–19

43 x 62¼ in

Oil on canvas

Musée d'Orsay, Paris

At the end of his life, for the picture planned as his testament, Renoir returned once more to the theme of bathers, which had preoccupied him for so long. Most of his paintings after 1900 concentrated on single figures. Here, however, he places two together, but not with any desire to differentiate, for both are taken from his favorite model Dédé – who became the first wife (and muse) of his son, the great film director Jean Renoir. The two large women are both embedded in nature and dominate it. The reds and browns of their bodies glow against the green vegetation like embodiments of – or allegories of – earth. Texture is no longer of great interest and the painting has a greedy directness and uncomfortable power that belie the age and infirmity of the painter.

The Late Paintings

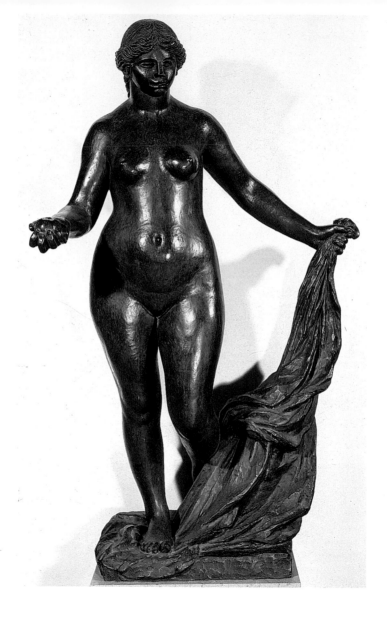

Venus Victrix 1914

71 in high

Bronze

Museum voor Schone Kunsten, Ghent, Belgium

This over-life-size bronze, modeled to Renoir's instructions by
Richard Guino, formerly an assistant of Aristide Maillol, is
probably the most impressive of Renoir's sculptures. By giving
this victorious Venus – a tribute to the power of the female – a
Latin title, Renoir alluded directly to Roman antiquity, even
though the heavy hipped, small-headed figure that he designed
bears little similarity with anything conventionally classical. There
is some link with preclassical Bronze Age figurines, but Renoir
replaces their chaste formalism with the palpable amplitude of
modern flesh. Ironically, this victory of the goddess of love was
completed on the eve of the First World War, in which Renoir's
two elder sons were wounded, and the victory that he just lived
to see was of a different kind.

Chronology

1841 Birth of Pierre-Auguste Renoir in Limoges

1854–60 Works as a painter of porcelain and blinds

1861-4 A pupil in the studio of the painter Gleyre, where he meets Bazille,Sisley and Monet

1864 Exhibits his first painting at the Salon

1867 Shares a studio with Bazille and Monet

1868 Success at Salon with *Portrait of Lise* (Folkwang Museum, Essen)

1870–1 Serves in army

1874 Participates in the first Impressionist exhibition and the successive ones of 1876 and 1877

1879 Exhibits again at the Salon; does not participate in the fourth Impressionist exhibition or the fifth, of 1880

1880 Meets his future wife, Aline Charigot

1881 The dealer Paul Durand-Ruel begins to buy regularly from Renoir and Monet.

1881–2 Travels to Italy, the south of France and Algeria; works briefly with Cézanne

1883 One-man show at Durand-Ruel's gallery

1884 Plans a Society of Irregularists

1885 Birth of first son, Pierre, later a famous actor

1886 Does not participate in the eight and last Impressionist exhibition; an exhibition of his work mounted by Durand-Ruel in New York

1888 Concerned about criticism of his attempts to change his style

1890 Renoir and Aline marry; Renoir's final appearance at the Salon

1892	Large retrospective exhibition at Durand-Ruel's gallery; visits Spain	1901	Birth of third son Claude, later a leading cinematographer
1894	Birth of second son Jean, later a great film director; acts as an executor for the bequest of Gustave Caillebotte	1907	Acquires property in Cagnes
		1910	Henceforth confined to a wheelchair
1895	Acquires a house at Essoyes; spends much time there over succeeding years	1913	Makes his first serious attempts at sculpture
1898	First visit to Cagnes in the south of France	1915	Death of Aline
		1919	Dies on December 3 in Cagnes
1900	Awarded the Légion d'Honneur; major exhibition in New York		

Picture Credits

La Loge, Courtauld Gallery, London/Bridgeman Art Library, London/New York; *Dance at Bougival*, Museum of Fine Arts, Boston, Massachusetts/Bridgeman Art Library, London/New York; *Dancing Girl with Castanets*, National Gallery, London/Bridgeman Art Library, London/New York; *The Engaged Couple*, or *The Sisley Family*, Wallraf-Richartz Museum, Cologne/Bridgeman Art Library, London/New York; *At the Theatre (La Premiere Sortie)*, National Gallery, London/Bridgeman Art Library, London/New York; *A Nymph by a Stream*, National Gallery, London/Bridgeman Art Library, London/New York; *The Parisienne*, National Museum and Gallery of Wales, Cardiff/Bridgeman Art Library, London/New York; *The Bathers*, Philadelphia Museum of Art, Pennsylvania/Bridgeman Art Library, London/New York; *The Umbrellas*, National Gallery, London/Bridgeman Art Library, London/New York; *Young Girls at the Piano*, Musee d'Orsay, Paris/Bridgeman Art Library, London/New York; *The Path through the Long Grass*, Musee d'Orsay, Paris/Bulloz/Bridgeman Art Library, London/New York; *Dance in the City*, Musee d'Orsay, Paris/Bulloz/Bridgeman Art Library, London/New York; *Seated Bather in a Landscape*, or *Eurydice*, Musee Picasso, Paris/Giraudon/Bridgeman Art Library, London/New York; *Pink and Blue*, or *The Cahen d'Anvers Girls*, Museo de Arte, Sao Paulo/Bridgeman Art Library, London/New York; *The Swing*, Musee d'Orsay, Paris/Giraudon/Bridgeman Art Library, London/New York; *Portrait of Mademoiselle Romaine Lacaux*, Cleveland Museum of Art/Giraudon/Bridgeman Art Library, London/New York; *Claude Renoir in a Clown Costume*, Musee de l'Orangerie, Paris/Bulloz/Bridgeman Art Library, London/New York; *Frederick Bazille at his Easel*, Musee d'Orsay, Paris/Giraudon/Bridgeman Art Library, London/New York; *Girl Reading*, Musee d'Orsay, Paris/Giraudon/Bridgeman Art Library, London/New York; *Ball at the Moulin de la Galette*, Musee d'Orsay, Paris/Giraudon/Bridgeman Art Library, London/New York; *Venus Victrix*, Museum voor Schone Kunsten, Ghent/Giraudon/Bridgeman Art Library, London/New York; *A Dance in the Country*, Musee d'Orsay, Paris/Roger-Viollet/Bridgeman Art Library, London/New York; *Bathing on the Seine*, *La Grenouillere*, Pushkin Museum, Moscow/Bridgeman Art Library, London/New York; *Two Sisters*, or *On the Terrace*, Art Institute of Chicago/Bridgeman Art Library, London/New York; *Portrait of Madame Charpentier and her Children*, Metropolitan Museum of Art, New York/Bridgeman Art Library, London/New York; *The Gust of Wind*, Fitzwilliam Museum, University of Cambridge/Bridgeman Art Library, London/New York; *Julie Manet with Cat*, Private Collection, Paris/Giraudon/Bridgeman Art Library, London/New York; *Parisian Women in Algerian Dress*, National Museum of Western Art, Tokyo/Bridgeman Art Library, London/New York; *Portrait of Rapha*, Private Collection/Bridgeman Art Library, London/New York; *The Seine at Argenteuil*, Portland Art Museum, Oregon/Bridgeman Art Library, London/New York; *Portraits of Children* or *The Children of Martial Caillebotte*, Private Collection/Bridgeman Art Library, London/New York; Bather, Kunsthistorisches Museum, Vienna/Bridgeman Art Library, London/New York; *Self Portrait*, Galerie Daniel Malingue, Paris/Bridgeman Art Library, London/New York; *L'Estaque*, Galerie Daniel Malingue, Paris/Bridgeman Art Library, London/New York; *The Bather at the Fountain*, Galerie Daniel Malingue, Paris/Bridgeman Art Library, London/New York; *The Saone flowing into the Arms of the Rhone*, Private Collection/Bridgeman Art Library, London/New York; *Young Woman Seated*, The Barber Institute of Fine Arts, University of Birmingham/Bridgeman Art Library, London/New York; *The Bathers*, Musee d'Orsay, Paris/Bridgeman Art Library, London/New York; *Boating on the Seine*, National Gallery, London/Bridgeman Art Library, London/New York; *A Bather*, National Gallery, London/Bridgeman Art Library, London/New York; *The Luncheon of the Boating Party*, Phillips Collection, Washington DC/Bridgeman Art Library, London/New York; *Dancing Girl with Tambourine*, National Gallery, London/Bridgeman Art Library, London/New York; *Alphonsine Fournaise at The Grenouillere*, Musee d'Orsay, Paris/Giraudon/Bridgeman Art Library, London/New York; *The Boulevards (Les Grands Boulevards)*, Private Collection/Bridgeman Art Library, London/New York; *Portrait of Ambroise Vollard*, Courtauld Gallery, London/Bridgeman Art Library, London/New York; *Arum and Hothouse Plants*, Oskar Reinhart Collection, Winterthur, Switzerland/Bridgeman Art Library, London/New York; *La Place Clichy*, Fitzwilliam Museum, University of Cambridge/Bridgeman Art Library, London/New York; *Yvonne and Christine Lerolle at the Piano*, Musee de l'Orangerie, Paris/Lauros-Giraudon/Bridgeman Art Library, London/New York; *Study. Torso, Effect of Sunlight*, Musee d'Orsay, Paris/Peter Willi/Bridgeman Art Library, London/New York.

Index of Paintings